GATEWAY TO THE WORLD
THE PORT OF NEW YORK
IN COLOUR PHOTOGRAPHS

William H. Miller

AMBERLEY

First published 2015

Amberley Publishing
The Hill, Stroud
Gloucestershire, GL5 4EP

www.amberley-books.com

Copyright © William H. Miller, 2015

The right of William H. Miller to be identified as the Author of this work has been asserted in accordance with the Copyrights, Designs and Patents Act 1988.

ISBN 978 1 4456 4823 1 (print)
ISBN 978 1 4456 4824 8 (ebook)

British Library Cataloguing in Publication Data.
A catalogue record for this book is available from the British Library.

Typeset in 11pt on 12pt Sabon LT Std.
Typesetting by Amberley Publishing.
Printed in the UK.

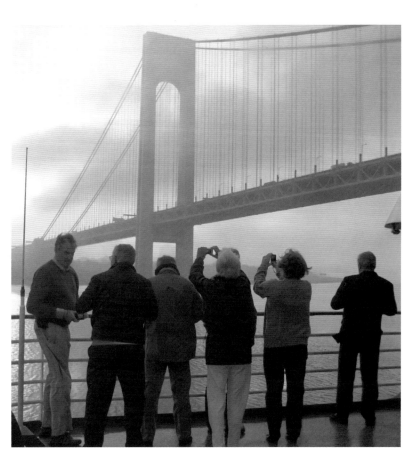

CONTENTS

FOREWORD

My father worked as a stevedore on the Hoboken piers for forty years, until his retirement in 1974. Somehow, as a second career (after a first career in the printing industry), I have followed him – as vice president of Ceres Atlantic Terminals, which, among others, operates the Cape Liberty Cruise Terminal in New York's Lower Bay, in Bayonne, New Jersey. Previously, Ceres also operated the Brooklyn-Red Hook Cruise Terminal, which, among other ships, handles Cunard and the giant *Queen Mary 2*.

As a boy in the 1950s, I well remember visiting my father on the Hoboken piers – first at the Holland America piers at Fifth and Sixth Street, and later at American Export Lines at Piers A, B and C, which stretched from First to Fourth Street. Perhaps most vivid to this day are the smells of those docks, a unique odour that has stayed with me for some sixty years. There were the smells of the burlap bags filled with loose cargo; the smells of wooden pallets, even the smells of oil and grease. There were also the smells of the individual cargos – olives in barrels, marble slabs and salamis from Italy, bags of peanuts from India and pistachio nuts from Sicily. There were also smells of wines from Spain, hemp from Portugal and oranges from Israel.

On the Holland America piers there were different cargos, including many foreign automobiles. There were Mercedes-Benzs and Volkswagens from Germany, and Renaults from France. There were also seemingly endless cases of beer, Heineken and Amstel, and lots of cheeses. My father, who was a 'hatch boss' and in charge of a 'gang' of twenty-one, sometimes took me aboard those immaculate Dutch ships, vessels like the *Noordam*, *Schiedam* and *Kinderdyk*. Sometimes, he also worked on Long Dock, the Ninth Street pier, where the likes of cased hams arrived from Denmark on the ships of East Asiatic Company and Polish Ocean Lines. There was also the Bristol City Line, which used the Eighth Street pier, bringing in woolen goods, whiskies and even bicycles from England.

American Export had a big yard in front of its three piers and the connecting pier head buildings. There was always activity there, and usually bustling activity. There were trucks, traffic congestion, cargo lifts and little cranes and even a connection to the feeder services of the Hoboken Shore Railroad. Railway boxcars were brought to the piers.

The cargo was discharged using the ship's booms. These booms were often connected by cables to the so-called 'home booms', steel lattice beams on the roof of the pier. My father had another name, 'spans', for these home booms. The cargo would be swung using pulleys. The dockers also used steel hooks to grab the burlap bags. The ships themselves would often list during loading and unloading. The dockers had to 'chock' the cargo in the deep holds. They used pieces of lumber to reduce the shifting of the cargo. Barges moored the outer side of the ships were also used for loading and unloading.

It was a three- to four-day process to offload and then another two to three days to reload, say, a 7,500-ton American

Export freighter like the *Expeditor*. Great canvas tarps would be erected in case of heavy rain. In deep winter, handling these ships was a bitterly cold process; in summer, it could be intensely hot. In winter, the ships themselves sometimes arrived covered in thick ice. The dockers would use sledge hammers to de-ice the winches. In deep winter, my father dressed in layers of clothing and some of the men wrapped their legs in newspaper as protection against the biting cold and frigid winds blowing off the Hudson. At any time, it was a dirty job; at the end of the day, the dirt would just flow off my father's hands and arms.

American Export's three piers sometimes handled as many as eight or nine ships at once. Some were berthed on the outer end of Piers A and C, while four ships could be berthed at 1,000-foot long Pier B. Uniquely, Export freighters were often berthed bow-out. This was said to be the preference of the company's marine superintendent, who felt it made for easier departures. Like many other companies, Export ships would arrive in Hoboken from Europe, Africa and the Middle East, and then go off on a seven- to ten-day 'coastal swing' – to Boston, Philadelphia, Baltimore and Norfolk/Hampton Roads. Then the ships would return to Hoboken, load a final outward cargo and then set off to overseas destinations.

In the 1950s and '60s, the dockers themselves in Hoboken tended to be Irish, Italian or Yugoslavian. It was tough to actually get a job on the waterfront. There was the 'Shape Hall' at the bottom of Hudson Street, near the Hudson Tubes station, where the men were hired. In 1960, my father was earning $10,000 a year, which was a considerable amount for that time. There were different hiring practices back then – some men worked and some didn't. The reforming Waterfront Commission changed all that in the mid-1950s. It was all brought to life and seen in the classic 1954 film, *On the Waterfront*. In reality, the dockers never worked after nine o'clock in the evening and only sometimes on Saturdays and Sundays.

Along River Street, the adjoining neighbourhood in and around the docks was all bars, one after the other. Some dockers went to the bars every day. There were also tenements, alleyways and backyard sheds.

Finally, it all began to change – and then changed completely. American Export-Isbrandtsen, as it was then called, moved to a Brooklyn pier in 1970 and the Concordia Line, Shipping Corporation of India and the United Fruit Company took over as tenants for the next decade or so. In the face of increased containerisation, however, the Hoboken docks closed to commercial shipping forever by the early 1980s. Pier B later collapsed into the Hudson, while Piers A and C were demolished in 1988/89. The area has since been gentrified – converted to parkland, office space and high-rise apartments.

In the 1950s, it was often said that a ship, usually a freighter, arrived or departed at the rate of one every 24 minutes around the clock. These days, it has all changed in New York harbour. More cargo is being handled in New York City than ever in history. Big containerships are mostly in and out in 12–14 hours and dockers earn a much better living now.

I am most fortunate to work on the waterfront. It remains exciting and always interesting. My friend Bill Miller has revived memories with another of his books, this one about New York harbour.

Anthony La Forgia
Vice President
Ceres Atlantic Terminals Inc.
Bayonne, New Jersey
Fall 2013

ACKNOWLEDGEMENTS

Like the great port itself, it takes many hands – like mates and pilots and deckhands themselves – to create a book such as this. As author, I am the general organiser and most grateful to all.

Foremost appreciation to Louis Archard and the staff at Amberley Books for taking on the project. Special thanks to Anthony La Forgia for his support, his generosity and his evocative foreword. Added thanks to Tom Cassidy, Anthony Cooke, Richard Faber, Michael Hadgis, Vincent Love, Miles MacMahon, James McNamara, Priscilla Norton, Richard Weiss, Robert Welding and Al Wilhelmi. Companies and organisations that have assisted include Crystal Cruises, Cunard Line, Hoboken Historical Museum, Holland America Line, McAllister Towing Company, Moran Towing & Transportation Company, Port Authority of New York & New Jersey, South Street Seaport Museum, Steamship Historical Society of America, World Ocean & Cruise Liner Society and World Ship Society, especially the Port of New York branch. My apologies for any and all omissions.

INTRODUCTION

When I lecture aboard modern-day ocean liners and cruise ships, one of my favourite talks is about my favourite place: New York harbour. It is a tour in photos, spiced with some facts, anecdotes and recollections. I took 90 per cent of the photos and, having taken some over forty years ago, it is great fun to see them come back to life in the shipboard theatres and lounges. Similarly, this book is not meant to be a formal history of New York harbour, but a tour in pictures. Aside from the lectures, it is now an added pleasure to share them in book form. It is, in a way, like being a passenger on a harbour tour boat.

New York harbour in the 1950s and '60s created the perfect show, like a huge stage production. Ships of every size and type came and went. It was said that a ship arrived or departed every 24 minutes. That certainly seemed true. There was the glorious cast of over 100 of the great ocean liners that came and went, often with predictable regularity. It was like a great timetable, one on which you could rely. The big Cunard *Queens*, the fabled *Mary* and *Elizabeth*, almost always sailed on Wednesdays. Others, such as Grace Line's *Santa Rosa* and *Santa Paula*, always sailed on Friday afternoons and, on Saturday afternoons, the *Queen of Bermuda* and her smaller consort, the *Ocean Monarch*. But there was also the countless freighters coming and going at all hours, from otherwise quiet Sunday afternoons to arrivals or departures deep in the night. It was all part of a well-known cast, like the familiar characters in a television soap opera, but an ever-changing cast.

Some ships, like the *Queen Mary* and *Queen Elizabeth*, came and went within 24 hours, while others, such as Cunard's *Media*, Holland-America's *Noordam* and American Export's *Excalibur*, stayed for six days, or even a full week. Like a railway timetable, I followed the daily shipping schedules of the *New York Times* and long-gone New York edition of the *Herald Tribune*. Wanting to avoid expensive weekend overtime from the dockers, Fridays were the busiest days. Shipping lines wanted to get ships off and away by late Friday afternoon. Allan Liddy, who ran a maritime photo company called Flying Camera, once told me,

> On Friday afternoons, it was difficult to photograph outbound ships in a single view. There was often another ship just ahead or just aft. Sailings were almost in convoy formation. Alone, the Grace Line had four sailings every Friday, usually in the afternoon and for every week of the year.

Sometimes, four Grace ships will sail in formation, almost stern to stern.

While I began watching New York harbour and its ships as a young boy in the 1950s, I began taking pictures with a small, inexpensive, plastic camera in the mid-1960s. Simultaneously, I had just joined the newly formed New York chapter of the World Ship Society. Making new friends of similar interest, we'd go off together – visiting ships, riding ferries and enjoying

some small boat excursions, which also took us to many of the backwater nooks and crannies. It was all very fascinating. You almost couldn't take it all in. And we thought it would go on forever.

There was the inevitable change, the gradual but on-going decline beginning in the late 1960s. I was aboard a Circle Line charter boat to serenade the grand old *Queen Mary* on her final departure on an otherwise sun-filled September day in 1967. Thirteen months later, we followed the *Queen Elizabeth* out for the last time. On a May morning in 1969, onboard another charter boat, we welcomed the new *Queen Elizabeth 2* – modern, sleek and representing a new age in ship design and operations. A curtain had closed with those older *Queens*; it reopened to a new, different production with the likes of the *QE2*.

As jets stole passengers from increasingly empty Atlantic liners, the age of efficient containerisation in cargo shipping changed the face of New York's inner harbour. One by one, liner companies withdrew, with some closing down completely. Some freighter companies joined the container age, while others disappeared completely. The once busy piers lost their tenants and then closed, often slipping into abandoned neglect. Shipyards, tugs, barges and almost all assorted craft declined drastically.

I recall a summer's afternoon, in 1975, when we returned from a cruise to Quebec City, the Canadian Maritimes and Boston, aboard the Soviet liner *Mikhail Lermontov*. As we sailed into the Lower and then Upper Bay, and then along the Hudson River, I was taken aback, in fact all but shocked – New York harbour, the busy, pulsating, electric port that I had known for over twenty years, was gone. There were so few other ships in the port; the likes of the once crammed Hoboken shipyards were all but empty, and the clutter of small working craft on the river were gone as well. It all seemed like a Sunday afternoon.

This book is intended to be something of a tour of the waterfront, the way it used to be, with reminders from a bygone era and parts of the great stage set that, I feel, also included the bridges, the skyscrapers, even those long-ago shipping offices along Lower Broadway. What a magical age! Thankfully, days with my camera in hand were plentiful, exciting and certainly happy.

Bill Miller
Hoboken, New Jersey
Spring 2015

Chapter One

ENTRY AND THE GREAT METROPOLIS EMERGES

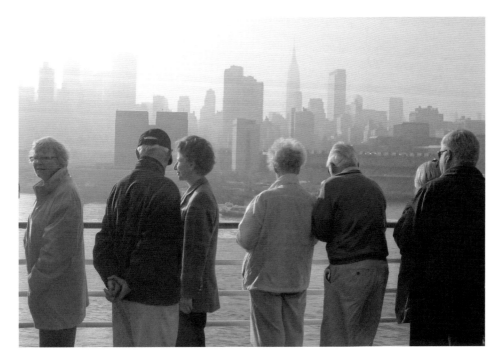

There is nothing quite like arriving in New York harbour. Even though I've done it several hundred times, it remains a magical experience. Especially in the early morning, as a ship approaches from the open Atlantic and passes under the Verrazano-Narrows Bridge, itself as if a gate to a kingdom, you can sense the electricity, the buzz, the great pulse of this extraordinary place. Passengers often rise well before daybreak so as not to miss the experience.

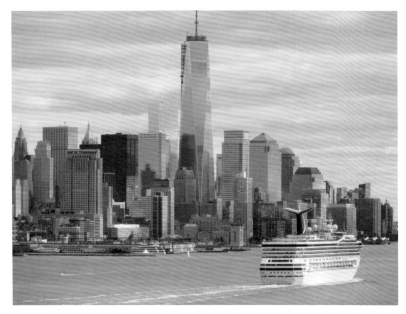

Especially in the early morning, from the deck of a ship, the light is quite extraordinary. It is an orange-pink at first with the yellow sunlight emerging over in the east. The city rises in the soft light. Equally, rain or light fog gives the city a more seductive, even more romantic feel.

Near the end of his life, in 2002, Alistair Cooke was asked to reflect on his greatest experience. The noted journalist, historian and TV personality, who had witnessed historic events, traveled worldwide and met countless celebrities and world figures, responded:

> It was a cinnamon-colored morning in October 1947. We were arriving from a war-weary, heavily rationed, very grey England aboard the *Queen Mary*. As we sailed into the harbour, the city emerged – this great, humming metropolis. Nothing could have better symbolized America and the future of the Western World in fact than that view. It was wealth and plenty, modernity, the future.

A frequent passenger on trans-Atlantic Cunard liners once told me, 'I have crossed to New York on dozens and dozens of trips. It is all quite wonderful, but the very best part of any voyage is arriving in New York harbour, seeing the city, feeling the great energy.'

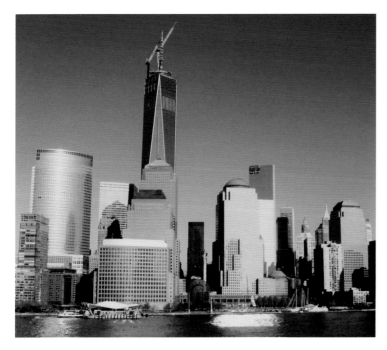

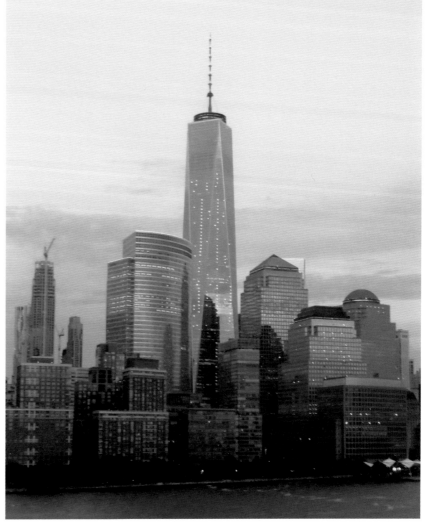

Above: The Lower Manhattan skyline is now capped by the new 1,776-feet-high World Trade Center, first opened in the fall of 2014. A top-floor observatory – with views for miles in each direction – opened its doors a year later.

Right: The $3.9 billion, ninety-five-storey structure, once thought to be called the Freedom Tower, has a shining beacon atop its telecommunications mast. Like the lighted lamp atop the Statue of Liberty, it is said to be a light of welcome, leading the way to the city.

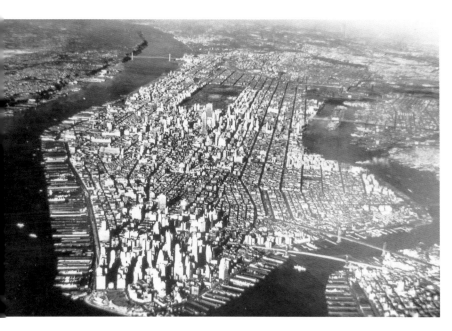

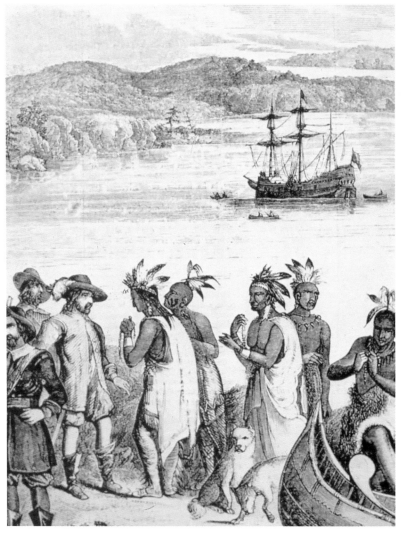

Above: This aerial view, dating from 1950, shows Manhattan Island: 35 miles around and once heavily lined with finger piers reaching into harbour waters. Passenger liners as well as cargo vessels regularly fed the city.

The Hudson River (also known as the North River) and New Jersey (Jersey City, Hoboken, Weehawken and Edgewater) are on the left; the East River, Brooklyn and Queens are to the right. (Port Authority of New York & New Jersey)

Right: In 1609, the port was discovered and settled by the Dutch, who soon named it New Amsterdam. It had a fine natural harbour and very promising potential for fur trading. But within seventy-five years, it was passed over to the British and renamed New York. (Port Authority of New York & New Jersey)

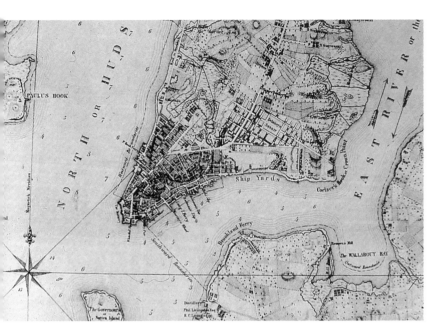

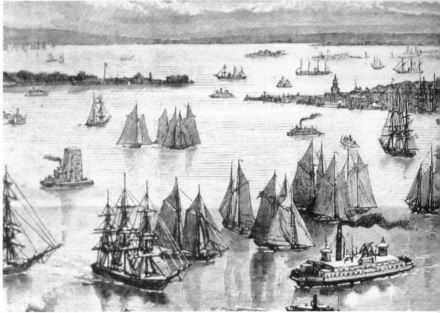

Below: By the 1850s, New York was the busiest port in a still largely infant America, the so-called New World. It was, for example, in a natural position for trans-Atlantic trade with the Old World. (Port Authority of New York & New Jersey)

Above: The first sizeable settlement was at the very bottom of Manhattan Island. Not expected to grow or expand, a wall at the north end was built. Soon a popular congregation spot, it eventually became Wall Street. The wall came down and the city pushed northward. (Port Authority of New York & New Jersey)

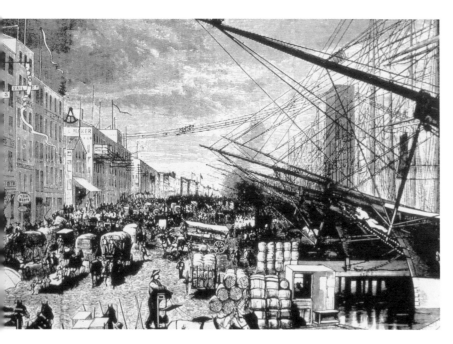

Above: The hub of shipping in the earliest times was along Lower Manhattan's East Side, around South Street, which was soon dubbed 'the street of ships'. Great clipper ships, used in the tea trades and carrying settlers seeking gold out on the west coast, moored there.

Below: Opened in 1883, the towers of the Brooklyn Bridge were then the tallest structures in the entire city. The 1,595-foot-long span was also a great symbol of American engineering, growth and ability, and of course hinted a promising future. (Port Authority of New York & New Jersey)

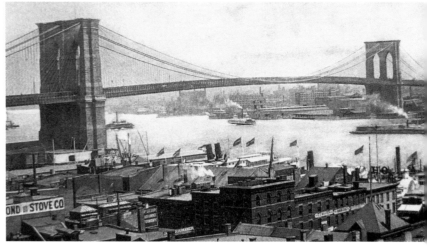

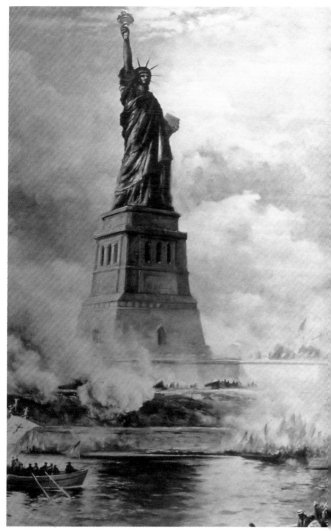

Above: Most shipping gathered along the lower East River, but, as vessels grew larger, there were difficulties with tides and turbulence. Companies such as Cunard soon relocated, moving west to the Hudson River. Others followed and, from the beginning of the 1850s, the Hudson was busiest waterway in the port. (Cunard)

Right: When opened in 1886, the Statue of Liberty – rising above the Upper Bay – was one of the city's tallest structures. Quickly, the statue was seen as the great symbol of the freedom that America offered. (Port Authority of New York & New Jersey)

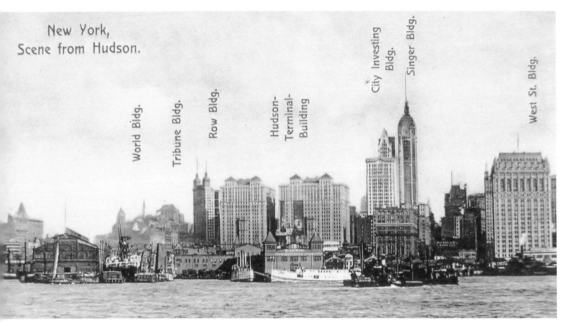

New York,
Scene from Hudson.

World Bldg.

Tribune Bldg.

Row Bldg.

Hudson-Terminal-Building

City Investing Bldg.

Singer Bldg.

West St. Bldg.

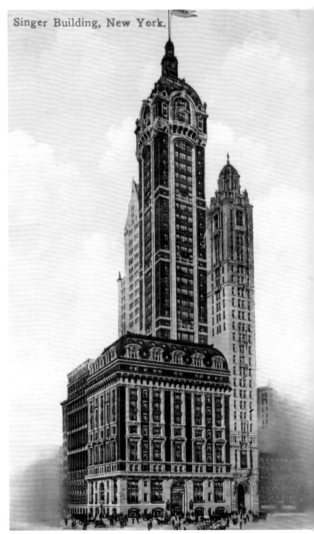

Singer Building, New York.

Above: Due to the strong bed rock and progressive development of the elevator, the city began to build upwards. By 1906, the forty-seven-storey Singer Building was the tallest in the world. Borrowed from a description for the tallest mast aboard the great sailing ships, 'skyscraper' seemed an apt description of these increasingly taller structures. They became synonymous with the city. (Author's Collection)

Right: At 612 feet in height, the Singer Building – located along lower Broadway and owned by the famed sewing machine firm – began a race of sorts. Shunted to second place in only three years by the fifty-two-storey, 700-foot-tall Metropolitan Life Tower up on East 23rd Street, the Singer stood for over sixty years before it was razed in 1967, then ranking as the tallest building yet to be demolished. (Author's Collection)

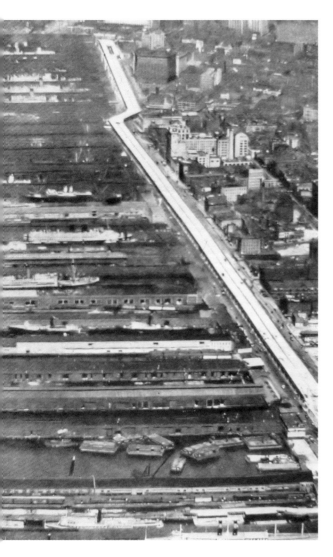

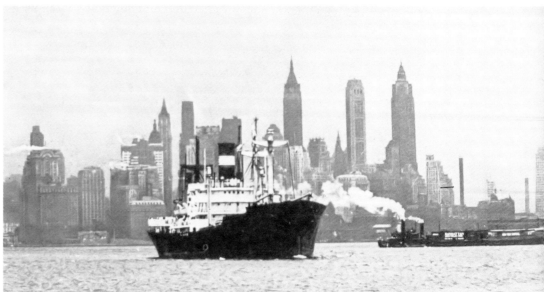

Left: The Manhattan waterfront boomed by the time this photo was taken in the 1930s. (South Street Seaport Museum)

Above: By 1955, it was said that a deep-sea ship of some kind arrived or departed in New York harbor every 24 minutes. (Port Authority of New York & New Jersey)

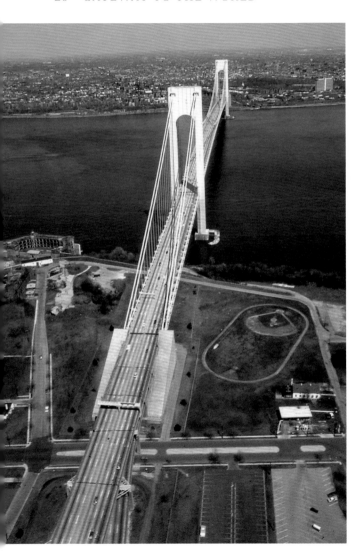

Left: In more modern times, the vast Verrazano-Narrows Bridge is seen as a great symbol of the port and the city. Opened in November 1964, it connects Staten Island and Brooklyn. It can be, however, the tightest squeeze: the towering, seventeen-deck-high *Queen Mary 2* regularly passes beneath but with only as little as 14 feet at high water.

Below: A small crew continuously paints the bridge each year and, after finishing twelve months later, simply repeats the process the following year. With Holland America's outbound liner *Maasdam* about to pass under, the bridge reportedly has a 6–8 foot differential in the height of the span. It is said to change in the extreme cold of winter, the high temperatures of summer and even sometimes with peak, rush-hour traffic loads. (Holland America Line)

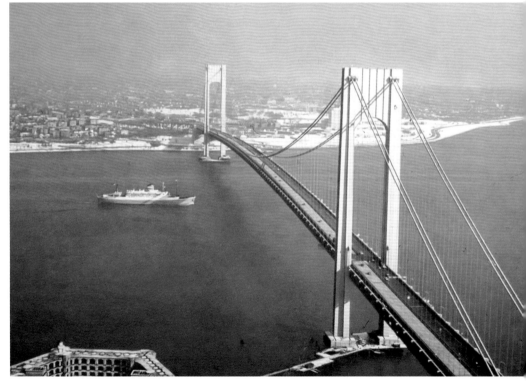

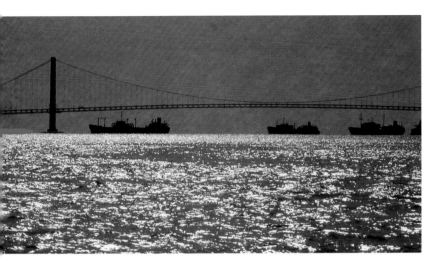

Below: A 20-minute ride between Manhattan and Staten Island on the famed Staten Island Ferry is like a mini-ocean voyage. There are huge numbers of commuters using these shuttling vessels, but also small armies of tourists. Once costing a nickel each way, it is now free and might just be the cheapest short 'ocean voyage' anywhere.

Above: The 4,260-foot-long Verrazano-Narrows Bridge has a slight curvature following the actual curvature of the earth.

The body just inside the bridge is known as The Narrows, which is not very narrow at all. It is here that ships (usually tankers these days) are often at anchor, awaiting an assignment to a berth. Earlier, in pre-First World War times, passenger ships anchored as well, for their lower-deck steerage passengers would be taken off, placed aboard ferries, tenders and even barges, and delivered to Ellis Island for formal entry. It was also here that some of the great convoys, often comprised of cargo ships, of the Second World War formed. It was also the area where flotillas of tugs, fireboats and other craft gathered to welcome, say, a new liner and then slowly escort it to a berth in Manhattan.

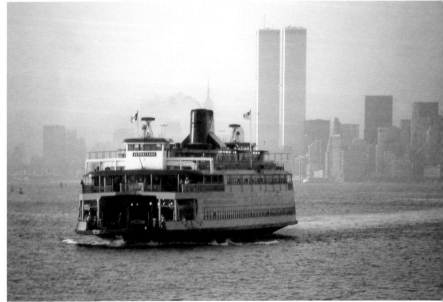

Above: The views from the decks of a Staten Island are so varied: the harbour in bright summer sunshine, or a misty autumn afternoon, or with the shimmering lights of a cold winter's night. Of course, just sitting watching ships come and go, as I did on countless occasions and such as this freighter (in 1972) bound for the far-off Orient did, added to the specialness of a ferry crossing.

Below: New York harbour's busiest, and perhaps proudest, day was 4 July 1976, America's bicentennial. Some 1,000 ships, including 200 Tall Ships, gathered in the port. Inspired by the late maritime historian Frank O. Braynard, the event caused some worry the month before. There were predictions of stampedes, overcrowded terraces falling from buildings and massive crime. Instead, there were no incidents, great friendliness prevailed and all but no crime. Several gala harbour occasions followed, including the 100th anniversary of the Brooklyn Bridge in 1983 and the 100th anniversary of the Statue of Liberty three years later, but none quite compared to the extraordinary success of Operation Sail in 1976.

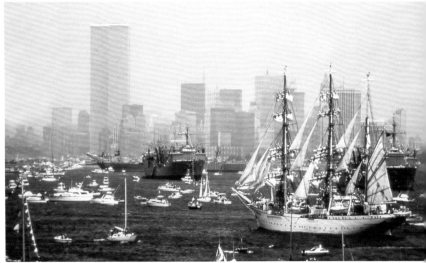

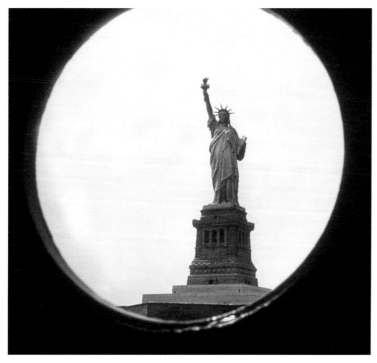

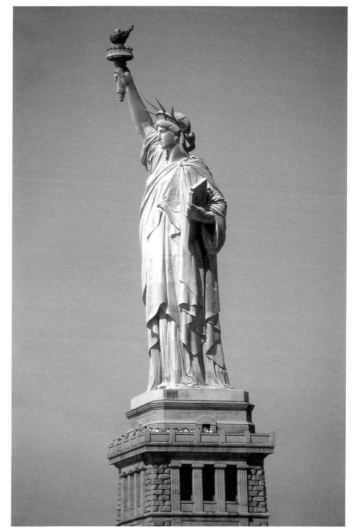

Above: Standing at 333 feet in height, the Statue of Liberty is a great, beloved symbol of America. Commodore Ron Warwick, master of the *Queen Elizabeth 2* and later the *Queen Mary 2*, once told me, 'No other country [France] has given another country [America] a gift that became that other country's greatest symbol.'

Right: Statue architect Bartholdi is said to have used his mother's face and girlfriend's body for the design of the statue. Given a major refurbishment in the 1980s, the statue lends itself to many curious facts. Its thumbnail, for example, is said to be 13 inches wide. The mouth, however, is 3½ feet, which gives Miss Liberty the distinction of having 'the biggest mouth in all of New York'.

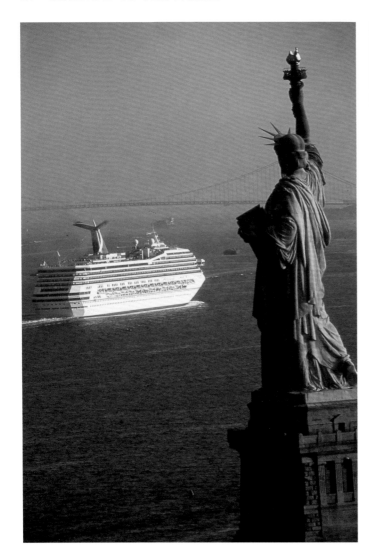

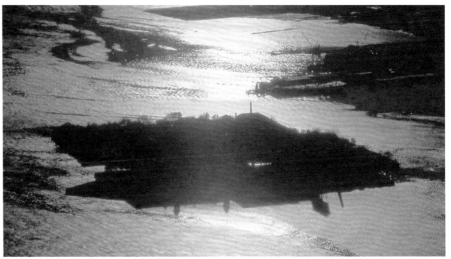

Left: A big Carnival Cruise Lines ship departs with the Statue of Liberty all but giving it a send-off. (Carnival Cruise Lines)

Located just north of the Statue of Liberty, Ellis Island was the nation's principal immigration station and entry point from 1892 until the government greatly slowed the inward flow of humanity in 1924 with national quotas.

Above: Ellis Island and the process of welcoming the greatest mass migration of people in the history of the world is a great chapter in the history of America.

Ellis Island

Between 1900 and 1915, 12.5 million immigrants crossed the Atlantic to the New World. In 1907 alone, at its peak, there were 1.2 million immigrants, and nearly 90 per cent of them made the journey, from six days to as long as three weeks, in Third Class or steerage. There were 1 million immigrants who came from Britain alone. They lived in crowded, sometimes poorly ventilated, lower deck quarters, often in dormitories. Usually, they were allowed out on the open decks for an hour each day.

At New York, Third Class and steerage passengers were unloaded from passenger ships that were anchored in the lower reaches of the harbour, known as The Narrows. These immigrant passengers were taken by tenders, ferries and even barges to Ellis Island, the US government inspection station situated just north of the Statue of Liberty. Only the First- and Second-Class passengers were permitted to remain and proceed to the Manhattan or Hoboken docks.

In 2001, I prepared the database of passenger ships, 818 in all, which carried immigrants to New York and through the doors and gates of Ellis Island. The project was inspired and underwritten by the Statue of Liberty-Ellis Island Foundation, which has been linked to the former immigration station since it opened as a museum in 1991. Heritage has become very popular, especially with younger Americans who are often keen to know of their roots and their predecessors who crossed the great Atlantic from the Old World to the New. Their interest often includes the detailing of, say, a great grandparent's journey and the ship they crossed aboard. The database therefore includes many recorded ships, from tiny, 1,500-ton vessels that were somehow pressed into immigrant service, and often with the most primitive quarters, to the likes of major liners such as the *Lusitania*, *Olympic* and *Imperator*.

Today, the museum on Ellis Island is a huge tourist attraction and an exceptionally popular one. More than a third of the people living in the United States today arrived via Ellis Island, or had relatives who did. To those earlier immigrants, the actual entry and inspection process was terrifying, even more so than the sometimes harrowing, storm-tossed ocean crossing itself. Ellis Island doctors, for example, were known as the 'six-second specialists', checking immigrants who showed possible symptoms of disease – heavy breathing, limping, coughing, even prematurely thinning hair. If a doctor made a chalk mark on an immigrant's coat, jacket or shirt (such as 'E' for eye), it often indicated need for further medical inspection. For the incoming immigrants, it was yet more fear.

In the second phase of the inspection and interrogation, immigration officials checked information that had already been collected by the steamship firms. In this often tense process, through misunderstandings and the diverse mixture of foreign languages, names were often changed. For example, Fishcov became Fishman. In other documented cases, occupations became last names: Cook, Baker and Miller to name but a few. Overall, only 20 per cent of all entrants were detained for further examination and, in the end, only 2 per cent were actually rejected and returned home. For those unfortunate souls, the steamship firms that brought them had to provide return passage. In June 2004, I attended the first Ellis Island Heritage Awards ceremony. That day, the most famous living immigrant among others was honoured. He was unable to attend on the day, however, due to ill health, but ninety-nine-year-old Bob Hope had, in 1909, come in Third Class from England.

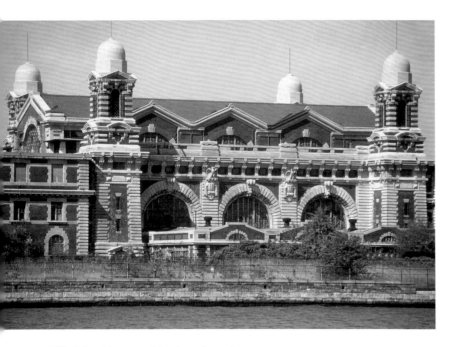
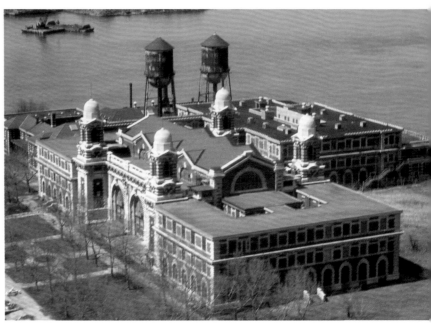

Ellis Island is capped by four domed towers.

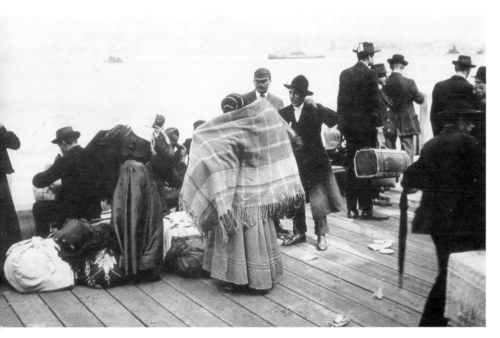

Immigrants – those 'huddled masses' – were arriving at the rate of 12,000 per day in 1907. (Ellis Island Museum)

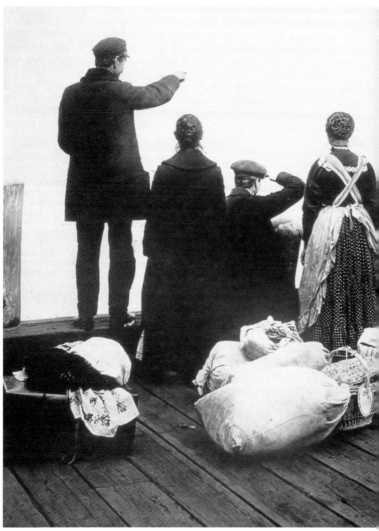

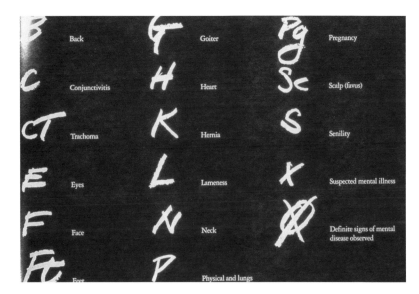

Back	Goiter	Pregnancy
Conjunctivitis	Heart	Scalp (favus)
Trachoma	Hernia	Senility
Eyes	Lameness	Suspected mental illness
Face	Neck	Definite signs of mental disease observed
Feet	Physical and lungs	

Above: The chalk markings indicating medical issues that were used by doctors and their staff on Ellis Island. Many immigrants had arrived by nine in the morning, been inspected and cleared by noon, boarded a ferry to Manhattan and then began working in, say, a Lower Manhattan factory by four o'clock the same day. Relatives or friends who had arrived earlier arranged for jobs. Many immigrants believed that in America, 'it was as if the streets were paved with gold': hard work lead to success. (German Immigration Museum)

Below: In the Great Hall on Ellis Island, immigrants waited, often worried and even frightened, but could see Manhattan just a mile across the harbour waters.

Left: When I first visited Ellis Island on a May afternoon in 1977, the place was a time capsule. It had been abruptly closed in 1954 and just left. Nothing, it seemed, had been done or touched in those twenty-three years. Typewriters on desks, lamps on tables and even medical instruments lay out and about. It was like a great Hollywood set, but a silent set – there were few signs of life.

Right: Retired in 1954, the last ferry lay derelict in this view dated May 1977.

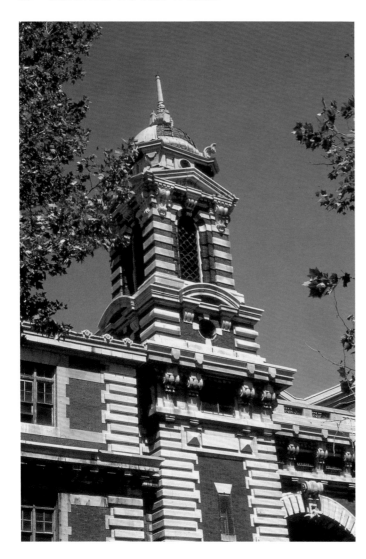

Since 1991, Ellis Island has been reopened as a superb museum and resource center, a tribute to the great immigrant process that built America. With heritage being much increased in the public's interest, it has become one of the top tourist attractions in the city.

DISTANT JERSEY SHORES AND THE 'BOX BOATS'

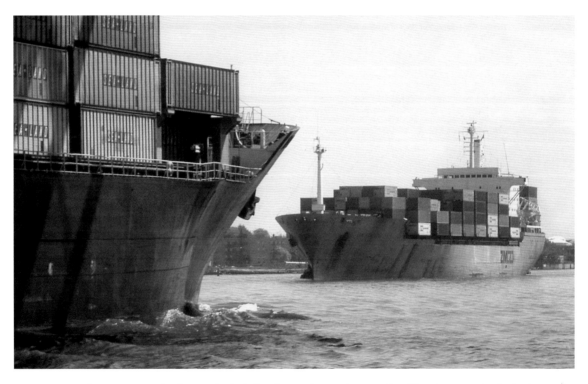

Beginning in the 1960s, with the gradual shift of containerised cargo handling in New York harbour, the waterway between Bayonne and Staten Island known as the Kill van Kull became increasingly busy. As container ships grew in size, their owners soon shifted to the more open facilities at Port Newark and Port Elizabeth in New Jersey (and also to Howland Hook on Staten Island).

Below: When the converted tanker *Ideal X* left New York on 26 April 1956, carrying fifty-eight cargo-laden truck-trailers on its specially fitted deck, containerisation was born. It would revolutionise the cargo handling business on the seas forever.

This first containership was the brainchild of North Carolina businessman Malcolm McLean, who bought his first second-hand truck back in 1934 and then steadily built it to a fleet of over 1,800 trucks, the largest in the South. As early as 1937, however, he noted that there was a considerable amount of wasted time when handling cargo on and off ships. Stevedores took far too long in handling the likes of sacks of coffee and bales of cotton. He thought it would be much more practical to lift whole trucks on and off ships. He also wanted to save taxes and avoid waterfront theft as well.

Historically, Seatrain Lines, on its New York–Havana run, had carried railway freight cars – 'box cars' as they were called – on its ships since 1929. But McLean envisioned an entirely new system: separating the truck-container from its bed and wheels, loading it aboard ship and then stacking these containers. By the mid-1950s, McLean moved out of the trucking business, bought Pan-Atlantic Tanker Company and soon reformed his operation as Sea-Land Shipping (then renamed Sea-Land Service, but later sold out to

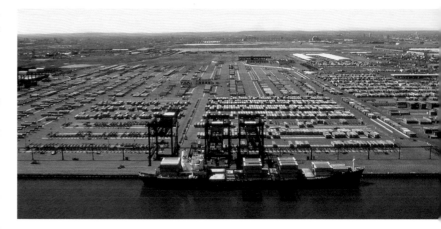

Denmark's giant Maersk Line). At first, the shipping industry cautiously watched McLean's operation, but soon realized its great efficiency and enormous cost savings. Great success and expansion followed. Modern-day mega-containerships (2015) can carry over 18,000 containers per voyage. The effect on worldwide trade has been extraordinary.

This view of the *Zim Montreal*, bound for Port Elizabeth, dates from 1974.

Above: A vast waterfront space adjacent to Newark Airport was purposely developed for freighters, and then containerships beginning in the 1950s.

Opposite page: Large containerships are handled by tall, bird-like cranes that can 'swing' sixty or more containers per hour. Concurrently, everything in the port has drastically changed with this system: suddenly, barges and lighterage were no longer needed, turnaround times for ships changed from days to hours and big, highly manoeuvrable containerships needed fewer and fewer tugs. By the 1970s, the face of New York harbour was dramatically different.

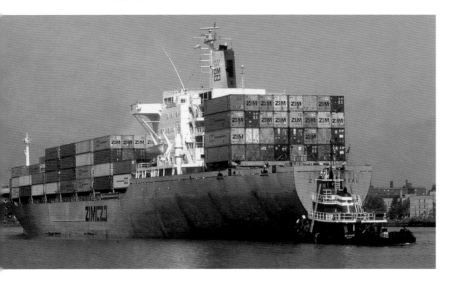

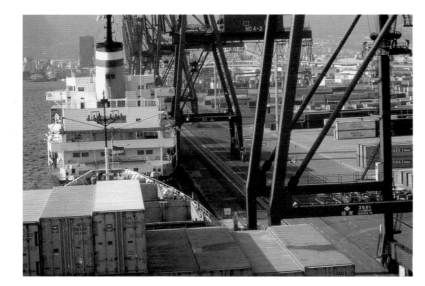

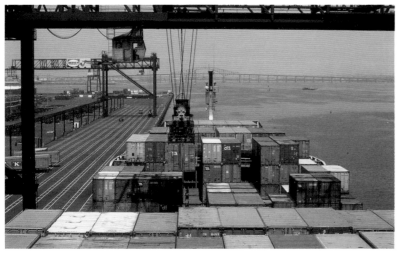

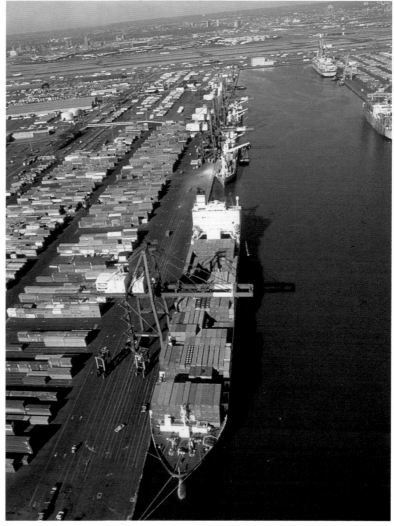

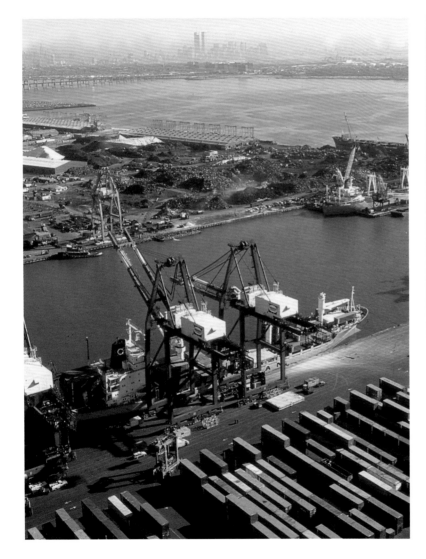

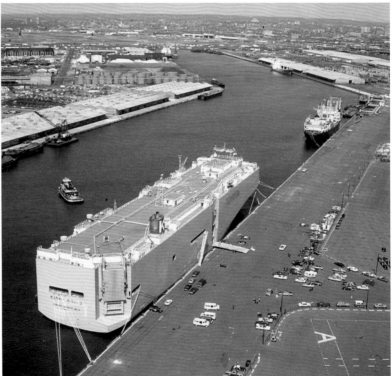

Left: In the first decades following the Second World War, America was the powerhouse of the world, shipping out everything from locomotives to crated automobiles. Within half a century, it had all reversed; the biggest exports out of New York harbour were scrap metal and used paper.

Above: Big, mostly Japanese-owned, car carriers began arriving in the 1970s at Port Newark. After three voyages across the Pacific from the likes of Yokohama and Kobe, they would deliver as many as 6,000 autos. They would be offloaded on the Newark docks, passed through formalities and then shifted to car dealerships.

Above: During the Second World War, the Federal Shipyard – located in nearby Kearny, New Jersey – built over 400 ships for the war effort. But when the conflict ended in 1945, the yard's great work all but halted and the plant might have closed. Instead, and for the next forty-five years, it was kept busy as America's biggest and busiest scrapyard. Several hundred ships – from ocean liners to harbour ferries – met their end along the docks at Kearny.

Below: With several thousand ships in reserve, the US government was the biggest customer to the scrap crews at Kearny. Among the ships demolished was the wartime-built carrier USS *Franklin D. Roosevelt*, photographed in the early 1970s.

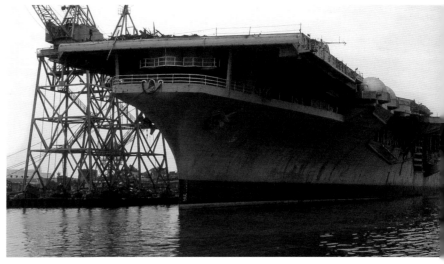

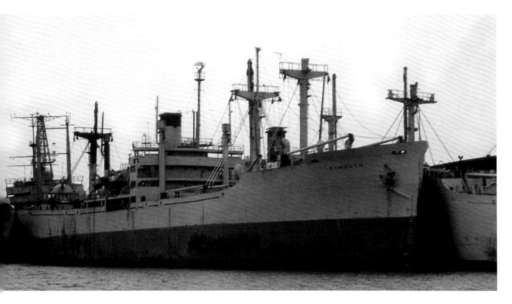

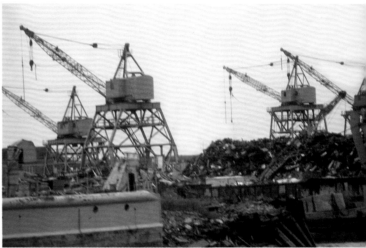

In the early 1970s, the scrap business was so brisk that ships had be moored across from the Kearny yard, patiently awaiting their turn for demolition.

Chapter Three

THE LOWER HUDSON AND PIER A

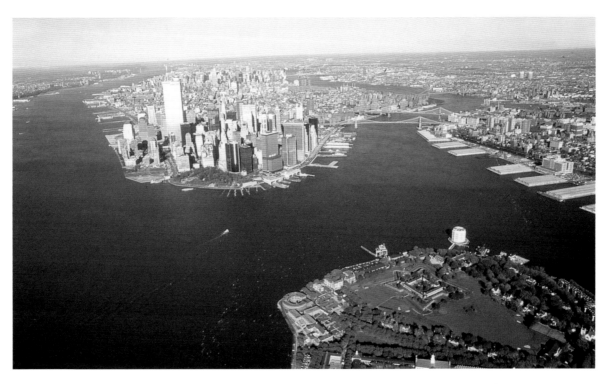

This aerial view of Lower Manhattan and the Lower Bay includes Governors Island, a tranquil island enclave that was used as a US coastguard base until 1997. After long discussions as to its re-use, the space became a public park in 2014.

Below: Battery Park, at the tip of Manhattan Island, was one of my favourite perches to watch the harbour, especially the passing liners. In this view, on a summer's afternoon in 1973, the superliner *France* is off on another trans-Atlantic crossing.

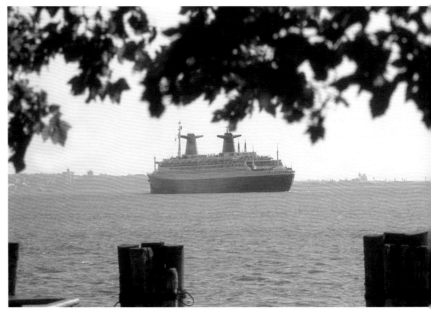

Above: Lower Manhattan has always been known for banking and, for many years, for shipping. The banking district, namely Wall Street, remains; the shipping offices began a mass exodus to less expensive suburban offices in the 1970s.

The city is said to be built on businesses remembered by the word 'fire': f – finance; i – insurance; r – real estate; and e – entertainment.

Pier A

Passengers arriving or sailing from Manhattan, and using the uptown piers, might notice Pier A at the very bottom of the city's waterfront. It juts out from a spot just north of Battery Park, at the very bottom of Manhattan Island. For some years now, however, it has been unused, and so seems neglected and lonely. But now there is news that the city, which owns the property, is looking into re-use, possibly for restaurants and shops, for the 500-foot-long pier.

Sitting in the shadows of huge Lower Manhattan towers, the pier might just be the oldest remaining along the Hudson. It was first built back in 1886; the clock tower, as a tribute to dead fighting men of the First World War, was added in 1919.

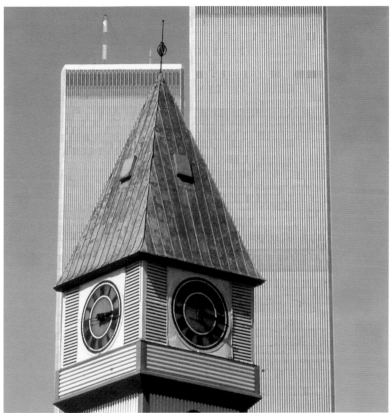

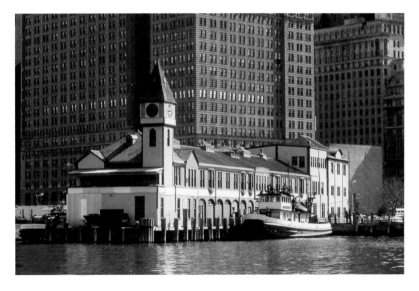

Among other roles, it had been used in more recent times as a berth for harbour fireboats.

Indeed, it would have been a great shame for such a fascinating structure to fall to the wreckers. Fortunately, by 2014, work had started on the pier to rebuild it as a restaurant and public space.

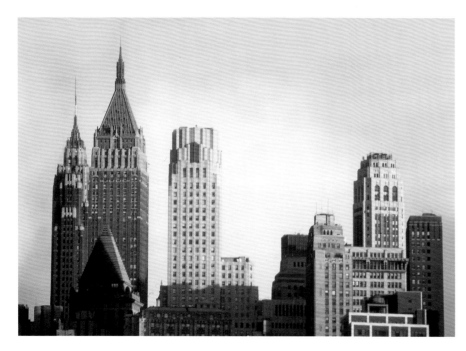

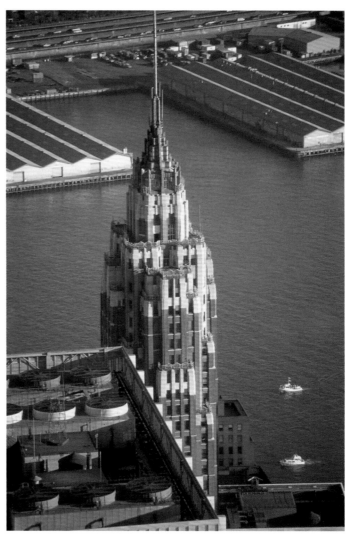

Above: Until the 1980s, Lower Manhattan was dominated – like the turrets of a mighty castle – by several, mostly art deco, skyscrapers. From left to right, in this view from 1973 there is the Cities Service Building (then fourth tallest in the city, at 950 feet and 66 floors); the Bank of Manhattan; Irving Trust Company; and City Farmers Exchange Bank.

Right: Completed in 1932, the Cities Service Building is one of the great art deco towers. Tall, slender and topped by a spaceship-like tower with mast, its style and design has often been described as 'jazz deco'. The building later became the headquarters of AIG and, in 2014, was converted into luxury apartments and a small hotel.

Below: There was an observation deck and corporate reception room on the very top of the Cities Service Building. The view, especially at night, was panoramic, and was said to include distances touching four states.

Above: The Cities Service Tower was built at 70 Pine Street, however it was not an especially prestigious address. In its early days, it could not easily be rented. The company soon bought a smaller building just opposite, which faced onto Wall Street – a very desirable address. Connected by a pedestrian bridge, the tower was soon renamed 60 Wall Street Tower and rented quickly.

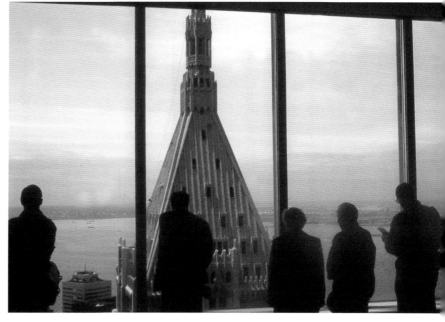

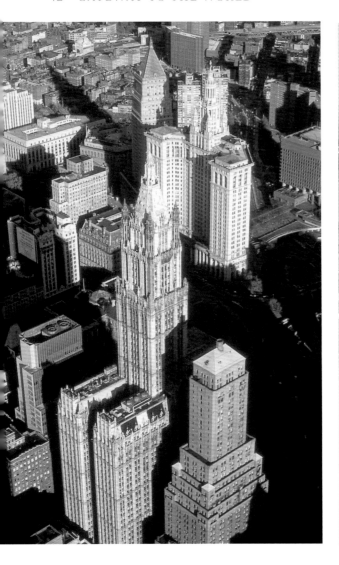

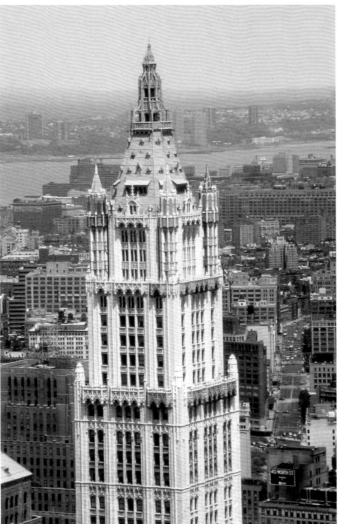

Left: Frank Woolworth built an empire with his five-and-dime stores and, by 1910, wanted a building to house his headquarters and symbolise his success. He also wanted a building so beautiful that it would come to be called 'a cathedral of commerce'. His architects used the Houses of Parliament in London for some inspiration. This view from the 107th floor observation deck of the north tower of the World Trade Center looks down on the sixty-storey Woolworth Building.

Right: When completed in 1913, the 790-foot-tall Woolworth Tower was the tallest building in the world. By 2015, being partially converted to luxury apartments (with the penthouse priced from $50 million), the stately structure was not even in the top 100 of the world's tallest buildings.

Left: Lower Manhattan, much like, say, London or Boston, is more of a higgledy-piggledy of streets – with names like Hannover Square, Peck Slip and Maiden Lane – and not the usual grid of most other parts of the city.

Above: The great banks of Lower Manhattan were often built to resemble strong castles and great fortresses to indicate to customers (especially in the worrisome Depression era of the 1930s) safety with their money. This is the imperious facade of the Cities Farmers Bank building, dating from 1930.

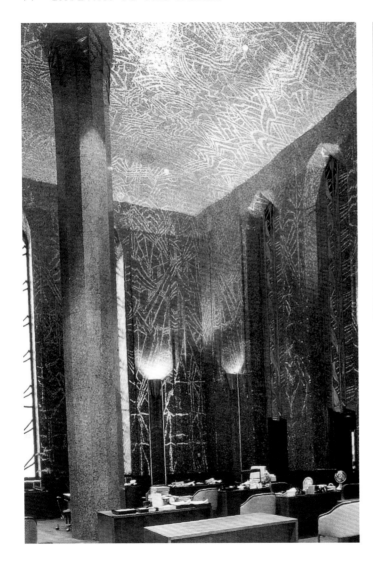

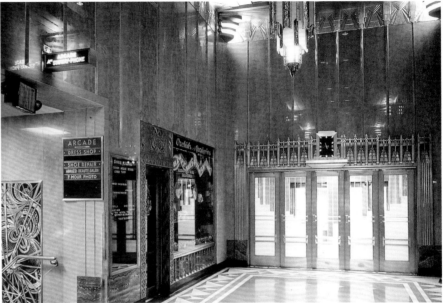

Left: Design and decoration of the great banks, and sometimes the great shipping lines, hinted of wealth, power, security and even luxury. The lobby offices of the Irving Trust Company, at the base of their fifty-storey tower at 1 Wall Street, included 33,000 pieces of imported Turkish gold tiles. These buildings really were twentieth-century cathedrals.

Above: Lobbies of many buildings were impressive: marble floors, art-filled walls, bronze elevator doors. The sense of entry was often impressive, special even, and slightly humbling. Visitors often tended to speak in hushed voices, even whispers.

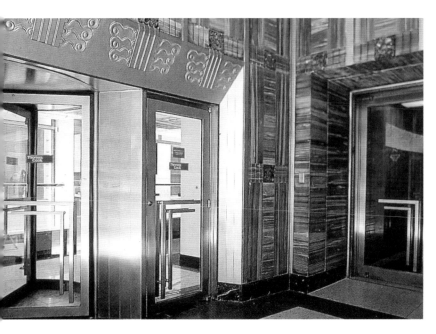

Revolving doors, glossy floors and gloved 'elevator ladies' were part of the busy world of Lower Manhattan – from Monday mornings until Friday evenings. On weekends, it was all quite empty. You could look along streets and not see a single soul.

Lower Manhattan's Steamship Row

As a boy back in the 1950s, my fascination for ships, especially the great ocean liners, first began as I so often watched shipping on the great Hudson River. I had my own perch from the shoreline of Hoboken, New Jersey, just across from the Manhattan piers. But I also travelled by Lackawanna Railroad ferryboats, or occasionally the Hudson Tubes, to Lower Manhattan for visits along 'Steamship Row'. The collection of offices was quite extraordinary. There was the United States Lines at 1 Broadway; Cunard at 25 Broadway; Holland America at 29 Broadway; American Export Lines at 39 Broadway and Home Lines at 42 Broadway. The likes of the Italian Line, Norwegian America and the Furness Bermuda lines were nearby, but over on Whitehall and State streets. The Greek Line was on Bridge Street and the French Line had a small office at 17 Battery Place. I regularly visited each and every one, collecting brochures, deck plans, sailing schedules, postcards and sometimes those large prints. I would often return heavily loaded with my maritime treasures. Often, I would read and reread the brochures, those sailings to far-away locations. Cunard, for example, represented lots of more exotic companies as well as lines such as P&O-Orient, British India, Union Castle and China Navigation. Their routings were even more distant. A long voyage on, say, P&O's *Arcadia* to Fiji seemed quite out of this world.

The steamship lines employed thousands in those downtown offices. Vincent Love, for example, joined the United States Lines in 1959. He'd come down to the 'big city' from Wellesley in Massachusetts. 'I joined United States Lines, which was then said to be the "Tiffany of steamship lines"', he recalled in a recent interview on a winter's afternoon in his high-rise apartment not far from Central Park.

I started in the so-called Pre-Paid Department. German immigrants mostly had their passages paid by relatives already in the United States. The relatives would visit our offices and I made the reservations, which were mostly in less expensive tourist class. It was actually quite a lucrative business for the United States Lines and my job included greeting them at Pier 86. There was lots of them, in fact, and on almost every arrival.

The United States Lines occupied much of 1 Broadway, a building that overlooked Battery Park and out to the Upper and Lower Bay.

United States Lines was still loaded with lots of White Star Line people from the 1920s and '30s. General Franklin, the chairman, was ex-White Star, and Ken Gautier, who headed the passenger department, was another former White Star staff member. 1 Broadway had been the White Star Line office, the International Mercantile Marine Building, the IMM. White Star was part of that huge consortium of shipping companies that once belonged to J. P. Morgan. White Star almost failed in the Depression until, in 1934, it was forced to merge with the Cunard Line and then moved over to nearby 25 Broadway and the huge Cunard offices.

In 1959, United States Lines was running two famous liners in trans-Atlantic service, the superliner *United States* and the smaller *America*, which sailed regularly to Cobh, Southampton, Le Havre and often to Bremerhaven as well. It was, in a way, a fiercely competitive business, especially after the first commercial jets flew the Atlantic beginning in the fall of 1958. Competition was now not just between the other steamship lines, but with a new, unbeatable competitor: the airlines. The airlines had, in fact, two-thirds of all trans-Atlantic business within six months, by mid-1959.

Vincent Love was later transferred to the conference department at US Lines:

We were a member of the Trans-Atlantic Steamship Conference, which had an office in New York and another in Folkestone in England. All passenger traffic managers met once a year and together set the passage rates by class and by season and by vessel. The ships were also rated by size and speed. The top rated was the *Queen Elizabeth* of Cunard, then the *Queen Mary*, *France* and then the *United States*. The age of the ships was also considered as was their size and speed. Once, the annual meeting was held at the Essex House Hotel during the Cuban Missile Crisis [October 1962] and the discussions concentrated on the possible 'end of the world'! There were also controversies such as one line wanting to advertise their 'new ship', but which was actually five years old.

The industry had its rituals and protocols. 'General Franklin arrived each day with his chauffeur and then took his private elevator up to the fifth floor', recalled Vincent Love, now retired,

The elevator was always waiting with a gloved attendant at the ready. 1 Broadway was a classic Manhattan office building with rather grand, if dated interiors. But during the '60s, there were modernisations and the marble counters where passengers bought tickets were smashed and removed, and then replaced by non-descript partitions. In ways, these were signs of the end. The money-losing *America* was retired in October 1964 [and sold to a Greek company] and then the *United States* soldiered on until she too was decommissioned in November 1969. It was all over for the Passenger Department at the United States Lines. I lost my job within weeks, by December.

All the great liner companies had offices in Lower Manhattan, but it was all collapsing by the 1960s. The jet had arrived in '58 and offered unbeatable competition. The Atlantic liners were soon struggling.

Cunard had the grandest offices in those days, at 25 Broadway, which were palatial and included an arcade of wonderfully large ship models. We were at 1 Broadway, Holland America was at 29 and American Export at 39. And there were many others. The French Line was the grandest, however, and their offices were far uptown, in Rockefeller Center. Along 'Steamship Row', we all knew one another. There were groups for drinks after five almost every day. Everyone looked after one another, even if we were competitors, and there was always a great sense of camraderie.

1 Broadway, a grand old office building overlooking Battery Park and just across from the ornate US Customs House, had belonged to the White Star Line, the owners of such ships as the *Titanic*, in prior years. 'There were huge basement archives. There were "tons" of material. Every letter and memo and plan and photo was there', recalled Love,

> I remember seeing a memo from the late 1920s stating that General Franklin, the president of United States Lines, preferred a Packard to a Cadillac at Newport News for the launching of one of the Panama Pacific liners. Sadly, lots of the files, including the vast photo archive, later vanished. Although the top management at US Lines was 'old guard' in the steamship industry, they did not care much about history or preservation. Even as late as the '60s, the *Titanic* and her tragic loss was never mentioned. Other archival materials went to a safe home, to the archives of the US Merchant Marine Museum at Kings Point on Long Island, New York. The late Frank Braynard was the great saver and keeper and charmer.

The managers – all 'old school' – were very conservative and many had worked for the White Star Line in the 1920s and '30s. They had grand, very spacious offices, some with the most panoramic views over the Lower Bay. They smoked Havana cigars even after the Cuban embargo of 1962. They were rarely open to new ideas of any kind. When someone suggested building new passenger ships in more efficient Japanese shipyards, one of the managers all but fainted.

Vincent Love worked in the passenger department at 1 Broadway, even if the Atlantic liner business was struggling more and more in the '60s. After 1964, the *United States* operated singlehandedly until she too was decommissioned in 1969. The American flag was off the Atlantic liner run. 'We had big berthing books in the reservations department and they were made of the highest quality paper because of the frequent erasures. Every entry was handwritten,' he remembered. 'In the office, they were known as "the book". It was always reviewed before sailing and the "commend list" was created for special passengers. "The book" would be taken to Pier 86 on sailing day and a second "book" created and given to a back-up.'

Within a month of the decommissioning of the *United States*, in December 1969, Vincent Love left the United States Lines. He soon returned to the passenger ship business, but in a new venture in the fledgling cruise industry. He signed on with Flagship Cruises with two new ships, the *Sea Venture* and *Island Venture*, and was with them until they were sold to Princess Cruises in 1974.

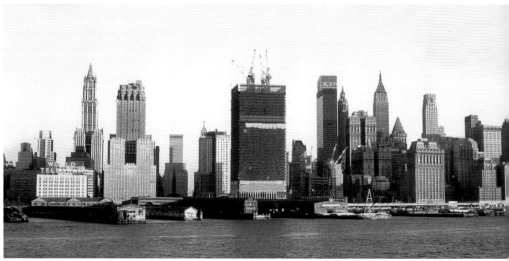

Left: In the early 1960s, the Port Authority of New York & New Jersey proposed a ninety-storey tower to consolidate shipping offices and related services. It would overlook the East River. New Jersey to the west, on the Hudson, complained. They suggested moving the project to a location overlooking the Hudson, and building not one but two towers, both even larger at 110 floors each.

Above: When the first tower began to emerge in the late 1960s, there was an outcry from some quarters. With an acre of space per floor, the new World Trade Center would overwhelm the otherwise stately Lower Manhattan skyline and its classic skyscrapers.

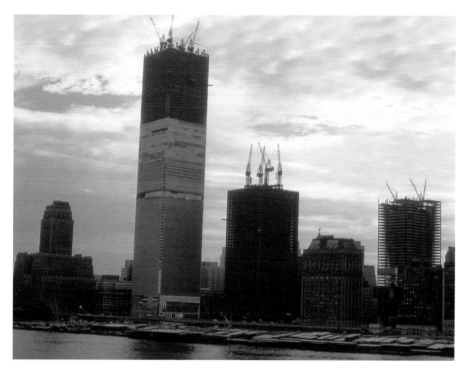

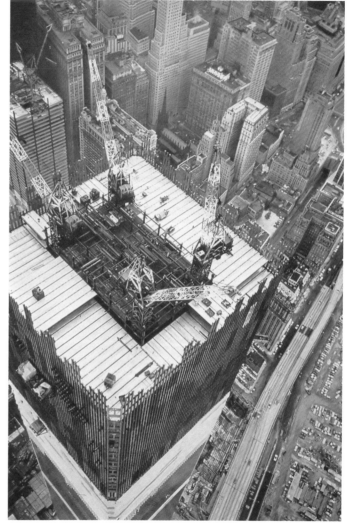

Above: Like knitting needles, the Trade Center rose almost by the day using Australian 'kangaroo cranes', which could be hydraulically lifted floor by floor.

Right: A dramatic photo of the North Tower under construction in 1970. (Moran Towing & Transportation Co.)

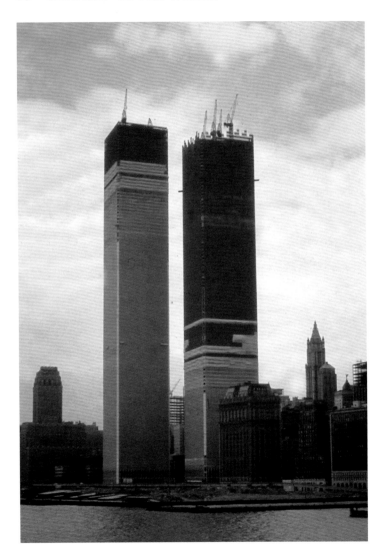

Left: In the end, removal of the four cranes was a question. One idea was to lower each of them by helicopter. Finally, the fourth crane lifted the other three down to the street. The fourth was later broken up into small pieces and sent down in large freight elevators.

Next three pages: Opened in 1973, the Trade Center was only half full at first, but went on to a 98 per cent occupancy rate. Myself, I worked in the offices of the Harbour Festival Foundation on the 86th floor of the North Tower for several years. It was a unique experience. On windy days, usually in fall, the building would creak and moan, much like a ship at sea, and a whistling arose from the fire stairwells. It was said that the towers 'swayed' up to 2 feet in high wind, but it was not something you could actually feel. Sometimes, in fog or on a day with low-lying clouds, we seemed to be lost in a world of total gray. Aircraft often flew past, sometimes at rather close range.

The towers had great distinction and notation. The North Tower, with its antenna, was the taller, measuring 1,727 feet from the street. There were 43,600 windows and the likes of 198 elevators and 40,000 doorknobs in each building.

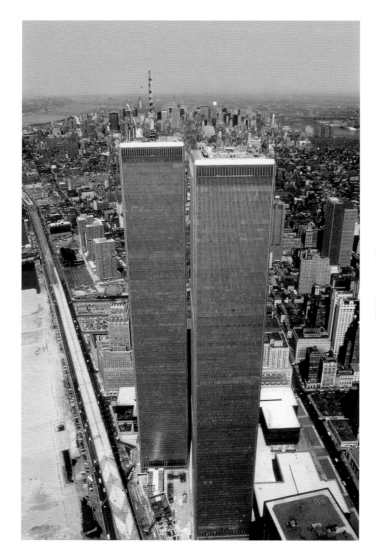

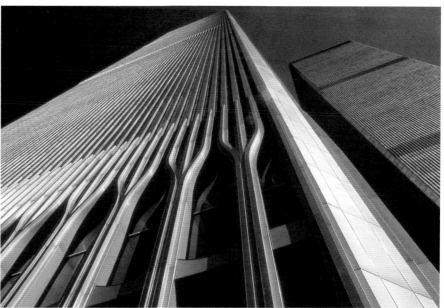

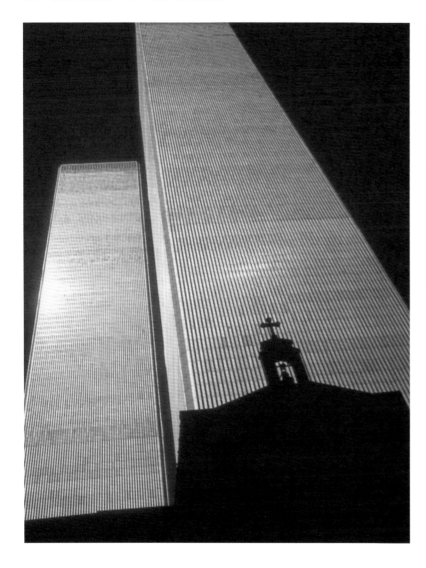

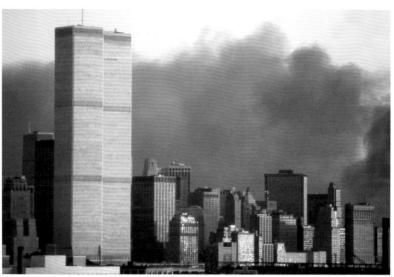

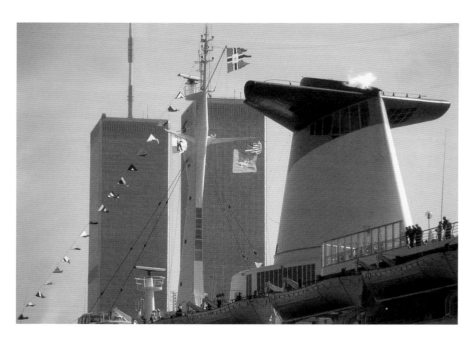

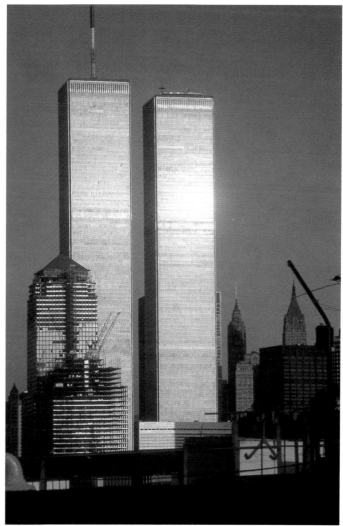

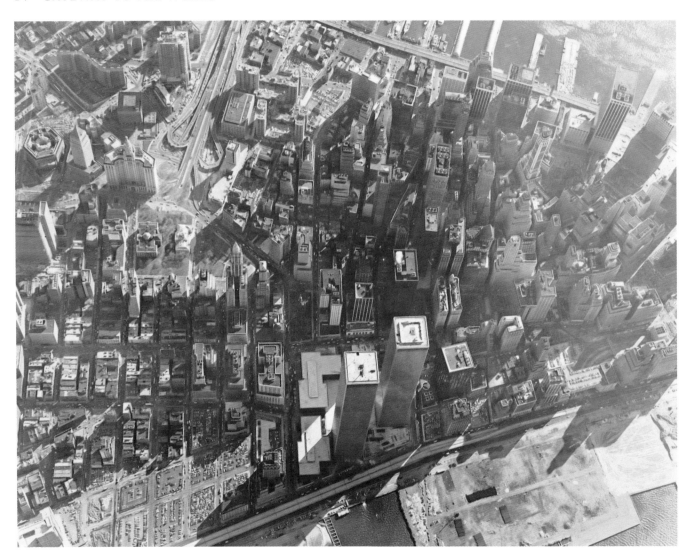

An aerial view of
Lower Manhattan,
1975. (Port Authority
of New York and
New Jersey)

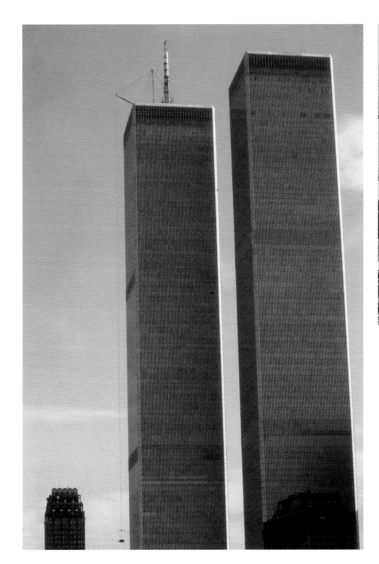

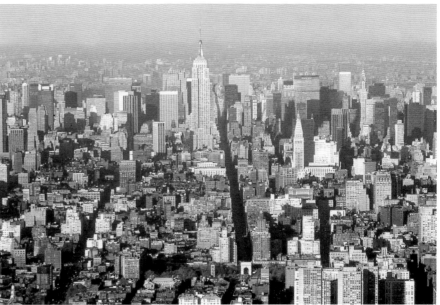

Left: The antenna was added in 1979. When I took this photo, on an April morning in 1979, a full flatbed truck was being lowered 110 floors to the street below. It had been loaded months before with sensitive equipment for the antenna and lifted upward.

Above: The views from the World Trade Center were spectacular. Looking north toward midtown Manhattan and the likes of the Empire State Building, and districts such as Tribeca, Soho and Greenwich Village, stretched out below.

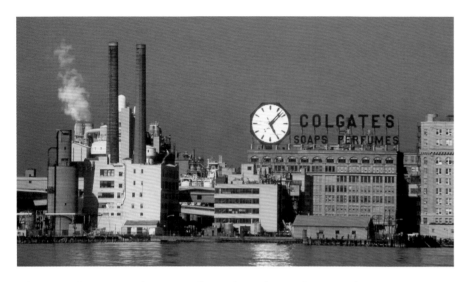

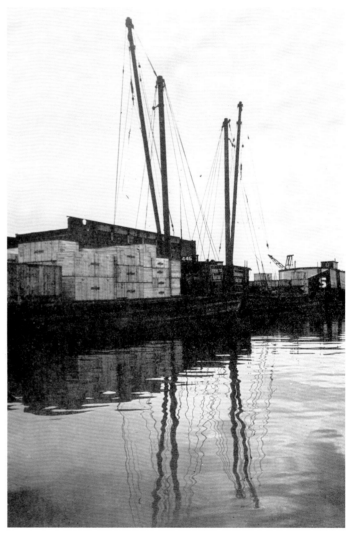

Above: Looking west: the Jersey shore along the Hudson was lined with industry, railways and shipping. It all began to change in the 1970s, with the decline of railway marine operations in the face of containerisation and the changes in American industry. In this view, we see the Colgate-Palmolive plant in Jersey City, which included the largest single-faced clock in the world (dating from 1921). The plant was pulled down in the early 1990s and replaced by office towers, luxury apartments and hotels.

Right: With the day's work complete, barges loaded with freight and with stick cranes for lifting wait at their Hoboken pier in this view from the 1950s. (Port Authority of New York and New Jersey).

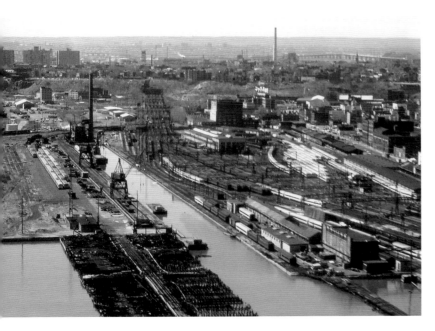

Above: Vast areas along the waterfront grew derelict by the 1970s and '80s, and these included abandoned warehouses, neglected piers and decaying, long out-of-use harbour craft. It all had a great sense of melancholy about it.

Below: With their voyages and purposes long over, out of work, mostly abandoned, craft of almost every kind sat along the Jersey shore, often for years. Their only sound of life was the slight creaking with changes of the Hudson tides.

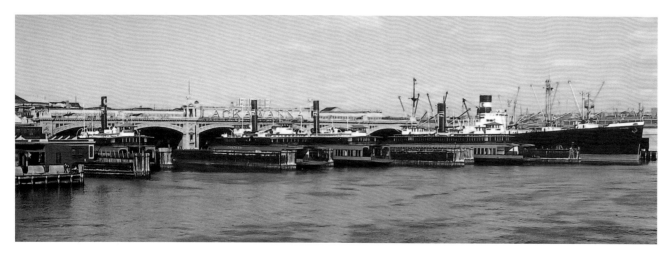

Left and below: The Lackawanna Railroad's Hoboken piers, including tugs, barges and ferries.

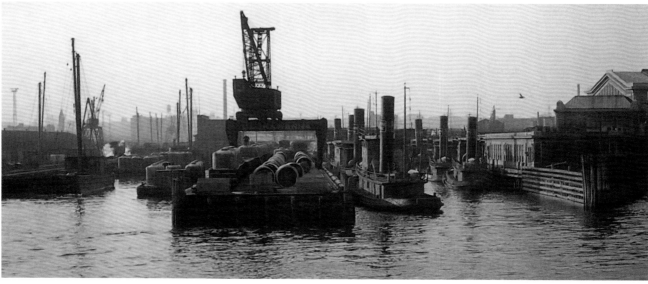

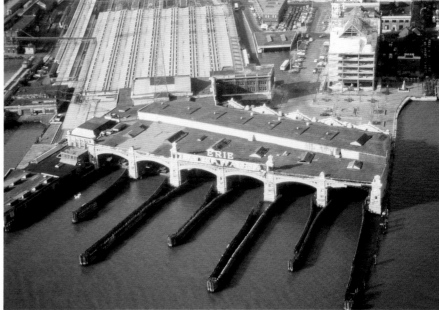

Below: Beginning in the 1980s, waterfront properties grew in appeal – they were ripe for redevelopment. Once distant waterside neighbourhoods became highly desirable with office towers, apartments, restaurants, marinas and parklands.

Above: A mile square, the author's hometown of Hoboken was once a teeming industrial, waterfront city, filled with factories, piers, shipyards, railroads and crowded tenements. In 1954, with 54,000 people living in that square mile, Hoboken ranked as the most densely populated city in America. The Lackawanna Terminal occupied the southwest corner.

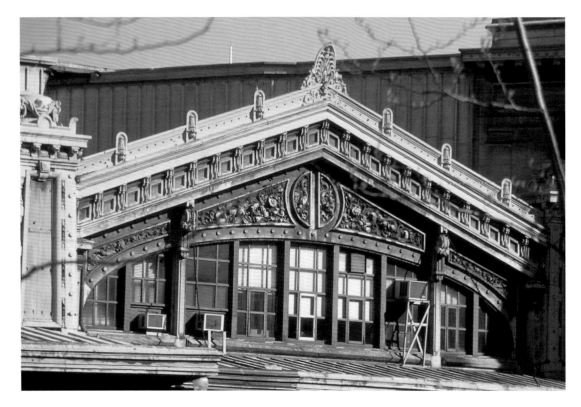

Found in Hoboken's south-east corner, Lackawanna Terminal was one of the great 'palaces of transport' – many trains, subways, buses and ferries provided services over to Manhattan. With a baronial waiting room included, the terminal, dating from 1907, was largely restored and upgraded beginning in the 1980s.

Hoboken and the Floating Palaces

A small monumental stone, the classic commemorative, stands along River Street in Hoboken, New Jersey. Along with the bustling traffic, it once faced the vast and busy docks. They're gone now, however, relics of a bygone era and, in the 1980s, victims of the wreckers' balls. The stone honours the countless American soldiers going off to war who passed through the Hoboken piers in that 'war to end all wars'. One of the great ironies was that the piers and terminal buildings had been German property, owned by the Hamburg America Line and the North German Lloyd. Some of their ships, including the giant

Vaterland, were seized when the United States entered the war in April 1917 and were restyled as ferry troops to fight the very nation and people that had created them. Even the Kaiser himself must have found this to be quite ironic. His pride, the 56,000-ton *Vaterland,* was now an Allied troopship, USS *Leviathan.*

Many Atlantic liners stopped sailing abruptly as the First World War erupted in August 1914. Often, schedules were left in chaos, with erratic crossings and some made with a sense of uncertainty and even less-than-safe conditions. The war was especially cruel, disruptive and even confusing to some of the greatest of the Kaiser's Atlantic liners. The innovative *Kaiser Wilhelm der Grosse* was a very early casualty. Quickly converted by the *Kaiserliche Marine,* the Imperial German Navy, just as the war erupted in the summer of 1914, she became a high-speed armed merchant cruiser. She was ordered to the Atlantic and sank two Allied merchant ships, but faced trouble when her coal supplies ran low. She put into Rio de Oro, a Spanish colony along the West African coast, but soon a British warship opened fire and the two engaged in a short, but fierce, battle. The German liner was no match and soon the first superliner was sunk and gone forever.

The *Kronprinzessin Cecilie* was eastbound out of New York on 29 July 1914 when news was received that war was imminent. Quite worrisome, she was not only carrying lots of homeward-bound Germans, but $10 million in gold bars and $1 million in silver, which were bound for the treasuries of Berlin. A safe passage to Bremerhaven seemed impossible and possible capture by the British unavoidable and soon the captain reversed course and sought the safety of a neutral American port. Not everyone onboard was pleased, however, and several First Class passengers offered to buy the liner on the spot (and for $3 million), raise the US flag and then sail onward to Europe. The captain declined and instead had the funnels repainted in White Star Line colours, thereby disguising, at least at a great distance, the *Kronprinzessin Cecilie* as the *Olympic,* the well-known sister to the *Titanic.* She fled to quiet Bar Harbour in Maine and dropped anchor there, much to the surprise of the locals who wondered why the big White Star liner had called unexpectedly. Of course, upon checking with officials at New York, word was flashed that the 'real' *Olympic* was in fact berthed at Pier 61. The German liner's identity was soon uncovered and the vessel was moved to Boston, where she was later seized and became the USS *Mount Vernon.*

Along with the giant *Vaterland* and a small armada of other German passenger and cargo ships, another four-stacker, the *Kaiser Wilhelm II,* was caught at her Hoboken pier when war in Europe was declared in August 1914. When America entered the war in the spring of 1917, she was restyled as the troopship USS *Agamemnon.* The remaining member of the original 'four flyers', the *Kronprinz Wilhelm,* was labelled 'the terror of the southern seas'. Altogether, she would sink fifteen Allied ships. She had been taken by the German Navy and dispatched to the South Atlantic, cloaked in various shades of disguising grey. Gone were her days as a peaceful, luxuriant express liner. In a sinister redesign, her outer decks now included powerful guns, while, inside, her once magnificent grand saloon was dismantled and converted to a huge coal storage hold. The smoking room underwent similar gutting, becoming a vast hospital ward with endless rows of beds and bunks. However, after months at sea, her condition deteriorated – there were leaks in the hull; her bow had to be plugged with cement; there was flooding and disease spread among her badly strained crew. She eventually fled to the safety of neutral America, to Norfolk, only to be seized and later repaired and then reactivated as the USS *Von Steuben.*

Mothballed after the war ended in November 1918, only three of these German greyhounds remained by the early 1920s. Idle in Germany during much of the war, the *Victoria Luise*, the former *Deutschland*, was declined as a prize of war in 1919 because of her poor mechanical condition and was allowed to remain with the Hamburg America Line. Repaired slowly, she was at the time once again the largest liner under the German flag. She reappeared as the demoted, twin-funnel, immigrant ship *Hansa* and returned to the Hamburg–New York run. But her days were numbered. She was sold to local Hamburg scrappers in 1925. Still in American hands, the former *Kronprinzessin Cecilie* and the ex-*Kaiser Wilhelm II* spent the remainder of their days in a tributary of Chesapeake Bay in Maryland. There were dozens of proposals to reactivate them, including as industrial trade fair ships and as refitted, diesel-driven liners on the North Atlantic, but for the United States Lines and in company with the far larger *Leviathan*, the former *Vaterland*. Yet nothing came to pass, and while the two ships might have been restored for further trooping on charter to the British in 1940, only the scrappers were seriously interested. Both soon finished their days at the hands of shipbreakers at Baltimore. Rusted, long ignored and mostly forgotten, this was the sad ending for those five once-glorious superliners; the first four-stackers, those first 'floating palaces'.

Hoboken's Fifth Street Pier

Back in the 1950s and very early '60s, mostly on Fridays at twelve noon, Hoboken would rattle with the thunderous steam whistles of one of Holland America's 'Big Three' – *Rotterdam*, *Statendam* or *Nieuw Amsterdam*. Moran tugs would gather at the bow, ready to push. Hemp lines at the ship's stern would be cast off first, and the aft end of the ship would begin to be eased away from the south side of the 800-foot-long Fifth Street pier. Then another blast on the whistles and the bow lines would be cast off, flash and splash in the Hudson, but then, dripping wet, would be smartly pulled aboard. The ship's forward section would now be free as well, and the vessel began to move slowly out into the mid-river.

Along Fifth Street pier's second-floor level, well-wishers – family, friends and the friends of friends – waved, cheered and lofted fluttering strands of those wonderfully coloured bon voyage streamers over the widening gap between ship and pier. The liner began to move, then slid backwards out of close view. Finally, in mid-river, with Manhattan's towers as a backdrop, the great liner would be pointed downstream and began her voyage – passing Hoboken and then Jersey City, Ellis Island and the Statue of Liberty, into the Lower Bay and the Narrows, then to the open Atlantic and ultimately to Europe.

Holland America's 'Big Three' included the *Nieuw Amsterdam*, a liner completed in 1938 that had that certain something – a blend of trans-oceanic chic, cozy comfort and decorative timelessness – that made her one of the most beloved and popular liners on the Atlantic run. She epitomized the Holland America Line slogan of the day: 'It is good to be on a well-run ship!' Hundreds of thousands agreed in those years, in the 1950s especially, loving the great leather chairs in the smoking room, the Moroccan leather ceiling and Murano chandeliers in the two-deck dining room, a First Class suite inspired by the 1939 World's Fair and, in one bar, brass door handles shaped like mermaids.

Holland America had other, if smaller, liners as well. There was the *Ryndam, Maasdam, Noordam, Westerdam, Veendam*

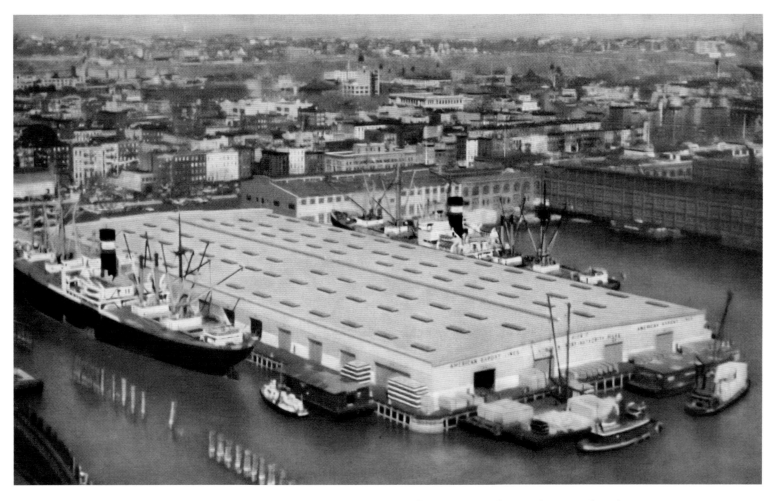

The Hoboken piers were leased to the American Export Lines in the 1950s and '60s. (Port Authority of New York and New Jersey)

and *Volendam*. And for the less luxurious, almost spartan, passages to and from Europe, there were the converted, former cargo ships *Groote Beer, Waterman, Zuikerkruis* and *Seven Seas*. These ships, with large cabins and dormitories that slept up to fifty, carried students, immigrants and frugal tourists – and often for as little as $125 for a nine-day passage to Rotterdam. Other Dutch liners that came to call at Hoboken in the 1950s included the *Willem Ruys*, the *Johan van Oldenbarnevelt* and the *Sibajak*.

Holland America also ran a sizeable freighter fleet, typically well-maintained, trim vessels that more often used the adjacent Sixth Street pier. The Hoboken longshoremen, those dockers immortalised in Hollywood's brilliant *On the Waterfront* (premiered in 1954), referred to them as the 'dyk ships' – vessels such as the *Sommelsdyk* and *Soestdyk*. The big liners, harbour legends such as the *Nieuw Amsterdam* and *Rotterdam*, were the 'dam ships'. The Fifth Street was the longer and better fitted, and so therefore handled the liners. The adjoining Sixth Street dock was for freighters mostly, the company's separate fleet of smart-looking, always immaculate, cargo ships, which also often carried up to twelve passengers each. They sailed the North Atlantic, to and from Northern Europe, and there were at least two sailings each week in those now distant, pre fast and efficient containership days.

Separately, the liners sailed between Hoboken, Southampton, Le Havre and Rotterdam. The freighters went to Rotterdam as well, but also to Antwerp, Bremen and Hamburg. Generally, they carried American-made manufactured goods over to Europe and returned with the likes of Dutch cheeses, Dutch tulip bulbs and Dutch beer. Holland America also carried the likes of the very first Volkswagen sent to the United States, which arrived in a wooden crate in 1949 at the Fifth Street pier on the 12,000-ton *Westerdam*, a passenger-cargo liner.

The glorious, twin-stacked *Nieuw Amsterdam* was surpassed as the Dutch flagship in September 1959 by the even larger, more luxurious, *Rotterdam*. But shortly after her maiden arrival (with the future queen of the Netherlands onboard as a passenger) on the Jersey side, the *Rotterdam* was towed across to Manhattan's Pier 40, then in the earliest stages of construction. It was a grand publicity stunt: having the world's newest liner berthed at the Port of New York's newest passenger pier. Pier 40 was also New York City's biggest marine terminal and certainly its most modern and innovative, with an inner core as well as rooftop parking, drive-alongside facilities and three instead of two riversides for berthing ships. The Holland America Line could hardly have refused the city's offer, and so abandoned Hoboken (after some seventy years), especially as the new pier was so easily accessible to midtown Manhattan.

The official transfer to the new Manhattan terminal was made by the *Statendam* in March 1963. She arrived and offloaded her passengers in Hoboken, but then, having been shifted across the Lower Hudson, sailed on her next outbound voyage from the brand new Pier 40 in Greenwich Village. But even those final years in Hoboken left an indelible mark. The stillness of cold, often frigid, winter nights, for example, might be interrupted only by the 10.00 p.m. departure whistles of a Holland America liner steaming off on a cruise to, say, the sunny Caribbean. On quiet Sunday afternoons, townspeople sometimes wandered down to the dockside to watch one of the ships tie-up. Each year, usually on a Thursday night, there would be a very special, 6-hour, charity cruise that sailed out past the 3-mile limit and where shipboard gambling was legal and formally dressed guests would party till dawn to benefit one or another worthy crusade against a disease. Limousines by the dozen rolled into Hoboken, reviving the gala ocean liner departures of years

past, often led by a troop of police on screaming motorcycles. Speeding up along River Street might be former President and Mrs Eisenhower, the Duke and Duchess of Windsor, and film queens such as Marlene Dietrich and Paulette Goddard. There might also have been Princess Grace of Monaco, fabled tycoons and classy heiresses, and, of course, the governors of New Jersey as well as New York. There would also be any number of television and theatre personalities on hand. Hoboken took it all in stride.

After Holland America defected to Manhattan, a small Portuguese freighter company rented the Fifth Street pier. But life was never quite the same. A few years later, these freighters moved away as well and the piers began to suffer a series of ruinous fires. Two relics of the Holland America Line survived, however, until the early 1980s on the remains of its Hoboken piers: the emblem of the Line, embedded in the former terrazzo floor of the main passenger entrance, but by then exposed to the weather and changing seasons, and a half-section of a green-and-white painted gangway. The remains were twisted, scorched heaps of steel and debris, and chunks of crumbling concrete. In the summer of 1980, a crane hauled away the final remains – along with a century of Hoboken's tradition as a great ocean liner port.

Today, the site of the Holland America Line has been gloriously revitalised as Frank Sinatra Park. Capped by spectacular views of Manhattan just across the Hudson, the area is now one of green spaces, shaded benches and sporting fields. Sadly, there are no reminders of the streamers and steamer trunks aboard luxury liners such as the *Nieuw Amsterdam* and *Rotterdam*, and the tulip bulbs and cheeses on freighters such as the *Sommelsdyk* and *Schiedyk*.

The campus of Stevens Institute of Technology, an engineering university, was positioned in prime real estate on a hill above the Hudson. For me, it was an ideal location for watching ships, say, departing on a Saturday afternoon. Here, we see Cunard's *Franconia*, outbound for Bermuda.

Below: Busy day along the Hoboken piers in 1951, with Cunard's *Media* and the Dutch *Zuiderkruis* and *Nieuw Amsterdam* at berth.

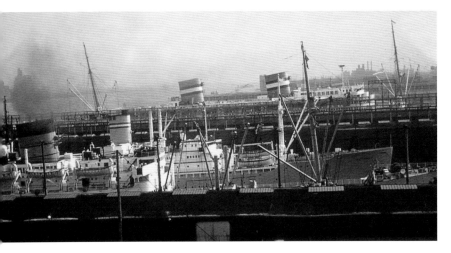

Above: Bound for a summer cruise to Scandinavia, the Swedish *Kungsholm* passes Hoboken in this late afternoon view from June 1973.

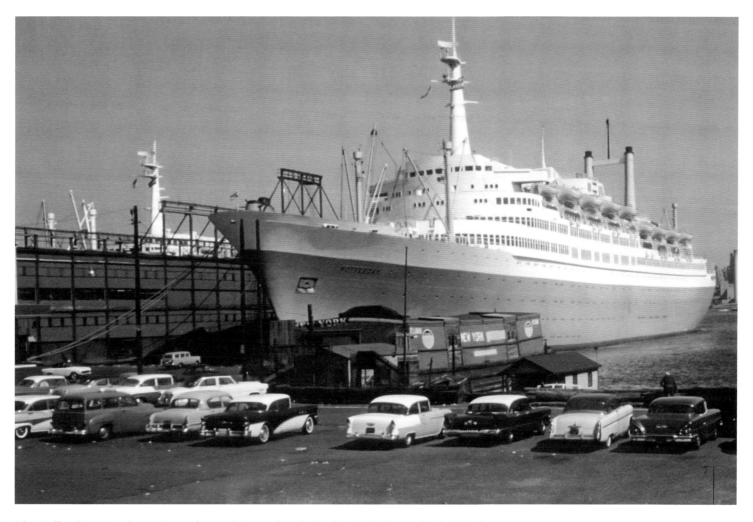

The Holland America liners *Rotterdam* and *Statendam* (behind) at Fifth Street pier in Hoboken, 1959.

Above: Below the Stevens campus was River Road, located on the same plane as the river itself. It seemed as if you could just about touch the passing ships, such as the departing cruise ships *Rotterdam* and *Doric* in this 1977 photo.

Below: Hoboken was a busy, crowded, tenement-filled city in the 1950s. Here is 'laundry day' in 1971.

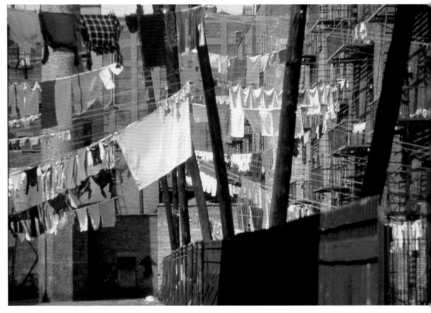

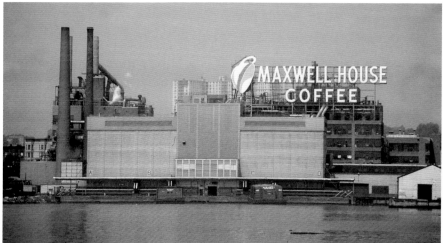

Left: Row houses and brownstones began to become popular and increasingly expensive by the 1980s. Hoboken was changing from a decaying industrial to an upmarket residential city.

Above: Maxwell House, the coffee-making plant constructed in 1939 and once one of the great industries along the Hudson, included a huge neon-lighted sign that faced Manhattan. It included a large cup and spelled-out the company motto: 'Maxwell House coffee – good to the last drop!'

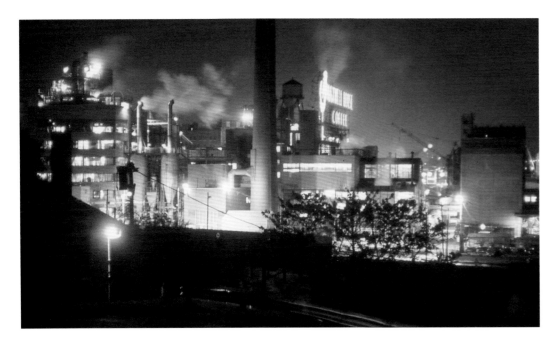

In past times, Maxwell House worked 24 hours a day for eleven months of the year. At peak, it was said to be producing the equivalent of 43,000 cups of coffee per minute. The plant closed in 1993 and was later demolished; rather typically, it has been replaced with a luxury apartment complex thoughtfully named Maxwell Place.

The Hoboken shipyards

The Hoboken shipyards have always been rather famous in New York harbour history. There had long been a strong connection to them: multi-national ships of all kinds at their docks, tales from the hectic wartime days and large 'gangs' of workers who came from throughout the metropolitan area. Following the Second World War, the two major shipyards, both sitting in the north-east corner of Hoboken, were Bethlehem Steel and Todd. Todd moved away in 1965 and centralised its harbour operations at its Erie Basin plant in Brooklyn. Bethlehem Steel stayed far longer, until 1984, after which it was sold and subsequently demolished in 1988/89.

The Bethlehem Steel facility was originally Fletcher, Harrison & Company, a Manhattan-based builder of boilers and engines, which opened in Hoboken in 1853. Some forty years later, it became W. & A. Fletcher Company and expanded from building harbour craft and coastal vessels to larger, deep-sea types. They also began building the Hoboken plant as it was for decades after. It was renamed United Shipyards in 1929, and then the facility was acquired by Bethlehem in 1938. The war years saw it at its peak, when over 4,000 ocean-going ships were

either repaired or converted for military service. This effort also included waterside units that handled big troopships such as the *Queen Mary* and *Queen Elizabeth*, both of which were far too large to berth at any of the Hoboken piers. It was not until the early 1970s that Bethlehem subleased a graving dock and repair facility at the Bayonne Military Ocean Terminal, so as to handle the likes of the 67,000-ton *Queen Elizabeth 2*, or a 1,000-foot-long Greek super tanker.

Until the 1970s, Hoboken was still rated as one of the best and most comprehensive repair yards, especially for marine engines, in all the United States. Buildings and piers stretched for some 1,700 feet along the Hudson River waterfront. There were welding shops, ones for copper and pipe; carpentry and sheet metal; eight-tower cranes; two floating cranes; a pair of small tugs; four dry docks; six separate piers; a tank-cleaning facility; offices and a power station; an on-site fire station and even a small hospital.

Long gone, the shipyard was replaced in the 1990s by luxury housing. Two of the buildings are named 'Constitution' and 'Independence', honoring the two big liners that used the Hoboken shipyard for their annual refits and overhauls.

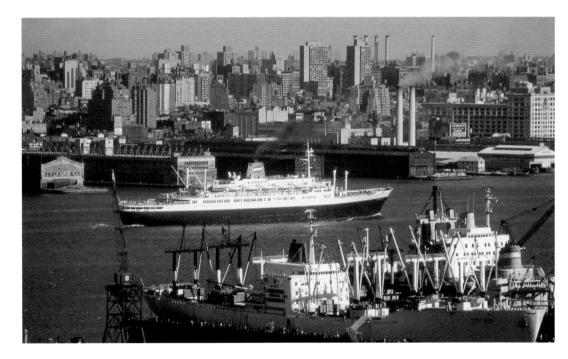

The Bethlehem Steel shipyard in the north-east corner once boomed, handling as many as fifteen ships at one time, using six piers and five floating docks, each being serviced by a pair of cranes. In this view, from June 1975, the *Statendam* passes by as the *Santa Rita*, *Export Defender* and *Austral Ensign* are being repaired at what we dubbed Beth Steel.

This and next two pages: All sorts of ships visited Bethlehem Steel – from big Atlantic liners and tropical cruise ships to freighters and warships. The liners seemed especially large, even towering and certainly powerful, when resting out of the water and in the floating docks.

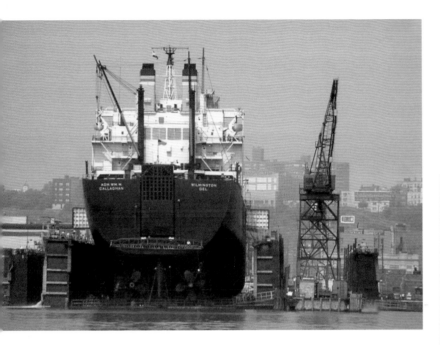

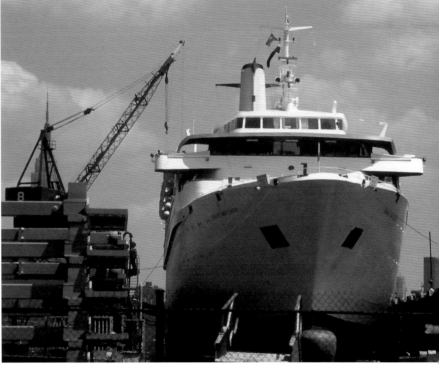

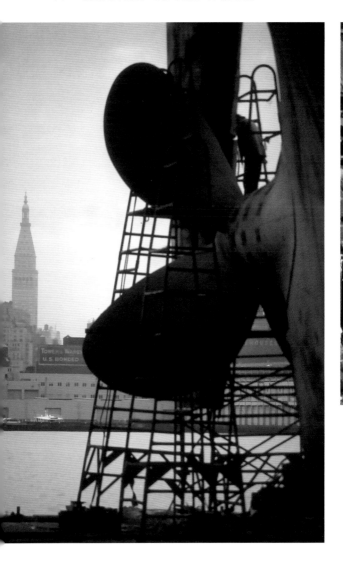

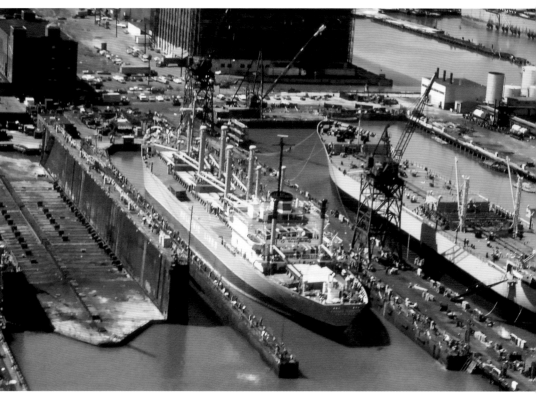

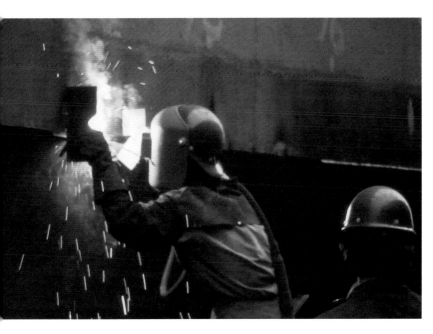

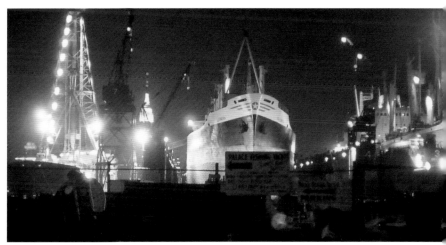

Shipyard crews often worked until midnight and sometimes through the night. The cluster and glow of lights created a sort of sound and light show. Even the lighted cranes were like surgeons attending to patients, the ships themselves. The flickering light of a welder's torch created a special production, a sort of staccato of colours on the sky above.

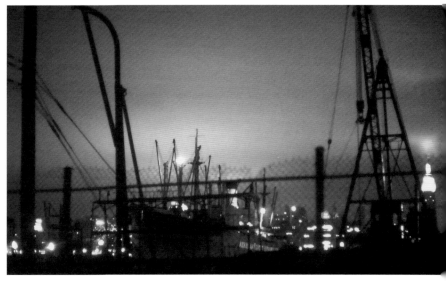

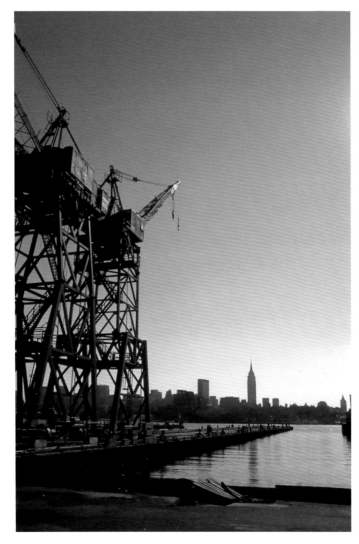

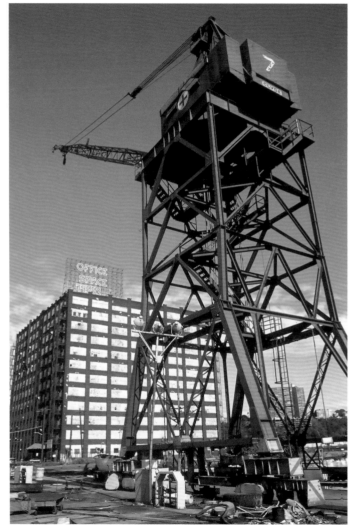

By the late 1980s, the Hoboken shipyards had closed. The once-busy cranes stood idle, the slips empty and the dry docks unused.

Foggy nights on the Hudson and looking over at Manhattan were especially evocative. The fog horns would go every hundred seconds, the skyscrapers were lost in a murky haze of low cloud and occasionally a dark, silhouetted freighter or tug and barge might slip past. It all had a great mood.

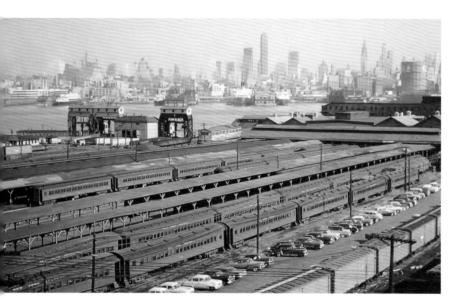

The once-booming railroad and ferry terminals at Weehawken.

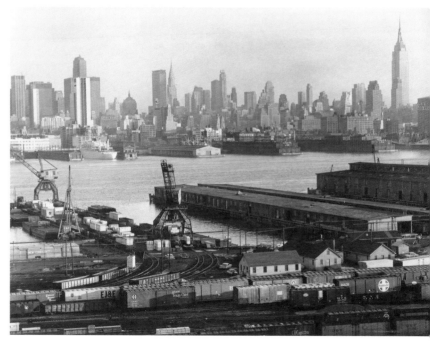

THE CHELSEA PIERS

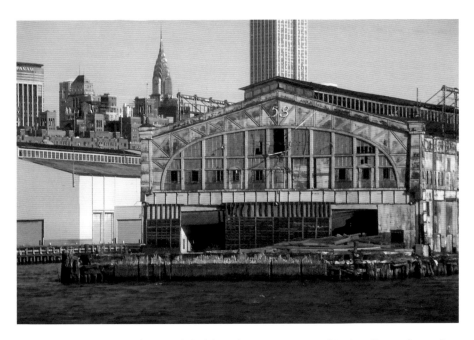

When containerisation first took hold in the 1960s, many shipping lines relocated to the more suitable and spacious areas of New Jersey City. The Manhattan piers lost their tenants, the city that owned them lost interest and then the piers themselves slipped into neglect. Some were vandalised, others victim to fire and still others collapsed and fell into the Hudson. This 1970s view of Pier 58, at the foot of West 18th Street, had been home to the liners of the Atlantic Transport, White Star, and French lines as recently as the 1930s. Passengers arrived from the cities of London, Southampton, Cherbourg and Le Havre. Later, it was used by the Grace Line until the late 1960s.

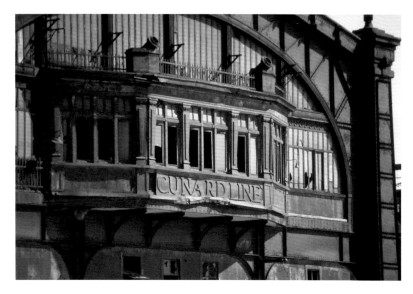

Below: Street-side entrances that once welcomed limousines, taxis and the luggage of outbound passengers were long closed and boarded shut by the time I took this photo in November 1983.

Above: The former Cunard Line piers, used by the likes of the *Mauretania, Lusitania, Aquitania, Berengaria, Olympic* and *Majestic,* and which received the survivors from the *Titanic* tragedy, were built in 1907–09. They handled the biggest, most luxurious liners afloat. But by the 1950s, they were relegated mostly to freighters; by the 1960s, they closed altogether. Thirty years of neglect followed before they were demolished and later revived as public park spaces.

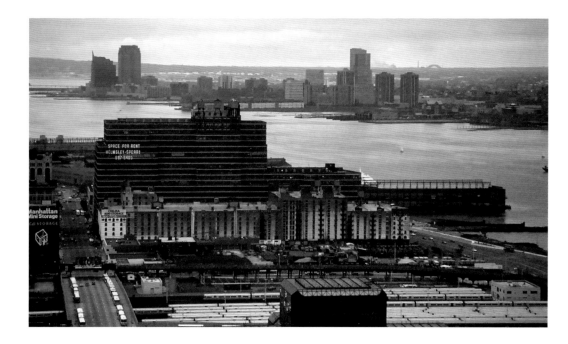

Several piers such as Chelsea piers survived, however, and were restored as marinas, restaurants, shops and even television studios.

Pier 57 and the Grace Line

On Friday afternoons in the 1950s and '60s, the proud passenger liners of the once very popular Grace Line departed. With steam whistles sounding, the sisters *Santa Rosa* and *Santa Paula* alternated their departures for the warm waters of the Caribbean. They ran thirteen-night itineraries, calling at Curaçao, Aruba, Cartagena and Kingston. Splendid ships that were yacht-like with intimate quarters and a mere 300 passengers, they departed from Pier 57 in New York City. Located at the foot of West 15th Street in the city's now much-gentrified Chelsea section, these days the pier has seen happier and certainly better days. The exterior is scarred and rusting in places, graffiti artists have done some work and numerous broken windows hint of closure and abandonment. With its gleaming stainless façade facing onto the mighty Hudson, the 900-foot-long terminal might see better, renewed days in future. There are plans of the day to renew the city-owned property with a museum, shops, food markets, small theaters and other public spaces. Cost of renewal ranges from $200 to nearly $500 million.

In its day, the pier was an engineering marvel and a highlight to an otherwise aging, worn, city waterfront. The adjacent Chelsea piers dated from 1907–10. The earlier Pier 57, used until the 1930s by the French Line, burned down in 1947 and so had to be replaced. The steamship business was booming and Manhattan boasted no fewer than 100 operative piers, jutting out like fingers. The new Pier 57 was built on a trio of floating, concrete caissons, which were actually constructed upriver, at Haverstraw, New York and then, in the care of a fleet of tugs, floated down the Hudson. This technology was inspired by the floating caissons used for beach landings in the Second World War.

The new Grace Line terminal formally opened in February 1954 and was highlighted for not only have the most advanced cargo handling methods (Grace Line had over two dozen ships, mostly freighters, in its US-Latin American services), but also for the novelty of rooftop parking for both passengers and staff. Grace occupied adjoining Pier 58 as well and, wanting to avoid high weekend, dockers' overtime, no fewer than four Grace Line ships usually departed before 5 p.m. on Friday afternoons.

But business as well as shipping was changing by the 1960s, especially with the inception of speedy container operations. Grace moved south to Pier 40, at West Houston Street and shared with the likes of the Holland America, Norwegian America and German Atlantic lines, in 1969. Pier 57 was transferred over to a non-shipping role, to the city's MTA (Metropolitan Transportation Authority), for use as a bus garage and maintenance facility. They finally moved out in 2004. The three-storey pier has been empty ever since.

By 2014, it was announced that Pier 57 would be made over as a public park, art museum and collection of shops and restaurants.

Friday departures from the Chelsea Piers: the United States Lines

Usually on Fridays, back in the 1950s, five or six freighters belonging to the United States Lines left the New York City docks and headed for Northern Europe. There might be the *American Forwarder* going to Dublin; the *American Leader* to Glasgow; the *American Scout* for London; the *American Harvester* to Antwerp and the *American Forester* to Bremerhaven. Usually, the piers were cleared before midnight Friday so as to escape the high weekend overtime charges. The US Lines were often quite empty on weekends.

These freighters were Class C-2 type design – 7,500 tons and 459 feet in length, steam turbine-driven of about 17 knots and, along with five holds of highly profitable cargos, they had space for twelve passengers comfortably housed in six doubles, each with a bedroom and private shower and toilet. A nine-day fare to, say, Antwerp was set at $150 in 1959. The ships tended to arrive and depart from Manhattan's Chelsea piers, numbers 59–62, between West 19th Street and West 22nd Street.

Vincent Love, who worked in the passenger department of the United States Lines mostly for the luxury liners *United States* and *America*, had a stint in the late 1950s of looking after the passengers aboard the freighters:

There were five, six, even seven sailings a week and each ship was full-up with twelve passengers. Lots of travellers liked them. They were less fancy than the liners and offered a more casual, relaxed way to and from Europe. Once, one of the freighters broke down outside New York and had to return to the Manhattan piers. I bought copies of the *Journal-American* and that pleased them. They read while the repairs were made.

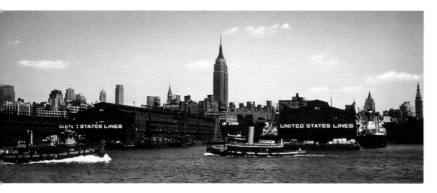

Above: The Chelsea Piers in the 1950s. (ALF Collection)

Below: An aerial view of the busy Chelsea Piers in 1949. (Port Authority of New York and New Jersey)

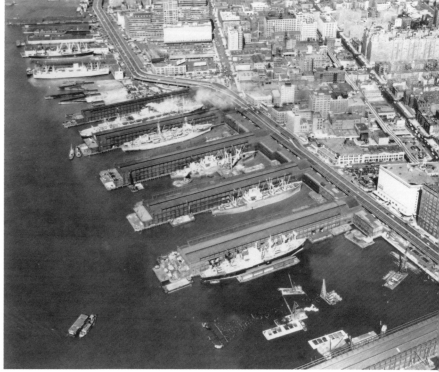

A fellow passenger aboard a recent cruise, Miles MacMahon, served as a radio officer aboard three of these ships – the *American Scout, American Forester* and *American Producer* – back in the 1950s. 'They were classic American freighters of that time,' he recalled,

> But they were also modified sometimes to suit their trades. The *American Scout* was specially fitted to go up the Manchester Ship Canal in England. The stacks and the masts were on hinges and so could be lowered for bridge clearances. The ships were kept in tip-top condition, always immaculate. They used the Chelsea Piers, No. 59 through 62, on Manhattan's West Side. Inbound from Europe, the ship would discharge cargo first at New York and then go off on a seven–ten day 'coastal swing' – calling at Boston, Philadelphia, Baltimore, Norfolk and Charleston. Then they would return to New York to finish loading for a return to Europe. All cargo was loaded in pallets and nets. There were no containers then.

Miles MacMahon was unique – he worked part-time, in the summers only, as a ship's radio officer. He was a high school physics teacher in New Jersey for the other nine months. He recalled,

> I made $5,000 a year teaching in 1960, but made more than that for three summer voyages on United States Lines. We'd sail to various ports – Hamburg, Bremerhaven, the King George V Docks at London. We also have other, special sailings. On the *American Producer*, I recall once going to western Europe – to St Nazaire in France and to Bilbao and Santander in Spain. There were three-week round trips. We carried twelve passengers on each ship and, in summer, we had lots of teachers onboard.

When US Lines began adding newer, larger freighters in the early 1960s, passenger quarters were not included. This disappeared after the older ships were retired, many of them finishing up on supply runs to south-east Asia during the Vietnam War and then, aged and exhausted, finished their days at Taiwanese scrap yards.

MIDTOWN MANHATTAN AND THE GREAT LINERS

This and next page: I miss the great activity that had been New York harbour. In my own nostalgia, I have over 1,000 1:1250-scale ship models and matching piers, all complete with miniature tugs and barges. These days, I 'recreate' those ship-filled days in New York.

Opposite left: Age of the great liners: A late afternoon departure of the *QE2* in June 1977. The great Cunard flagship passes midtown Manhattan and the Empire State Building. When completed in 1931, the 1,250-foot-high Empire State Building was the tallest building in the world.

Opposite right: Built in record time, the Empire State Building has 102 floors of space topped by an observation deck and viewing platform. A great symbol of the city, it is also a great symbol of the art deco style.

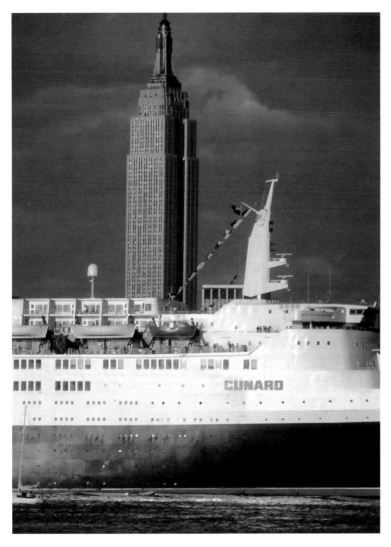

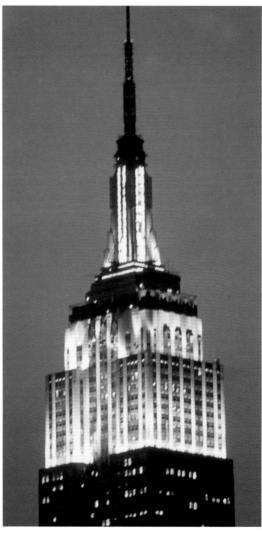

Left: In the 1930s, in the Depression, the building was quite empty, however. It was dubbed 'the Empty State Building'. The owners hired extra cleaning staff, so as to switch on night-time lights and make the building appear to be quite full. The antenna, in the new age of television, was added in 1950. It brought the building to 1,472 feet in height.

Right: The Empire State Building had up to eighty-five different lighting configurations, beginning with red for Christmas. It was changed to a new, very changeable and highly colourful LED system in 2014.

Left: Looking south from the top of the RCA Building on an afternoon in 1980, the Empire State Building seems the taller. In fact, the World Trade Center, with its antenna, was some 300 feet taller. When, in 1975, Chicago added the taller Sears Tower, the World Trade Center moved to second place, but was dubbed afterward as 'the world's tallest pair of buildings'.

Right: For the fiftieth anniversary of the Empire State Building in 1981, there was a 45-minute laser light show themed to a musical broadcast on radio.

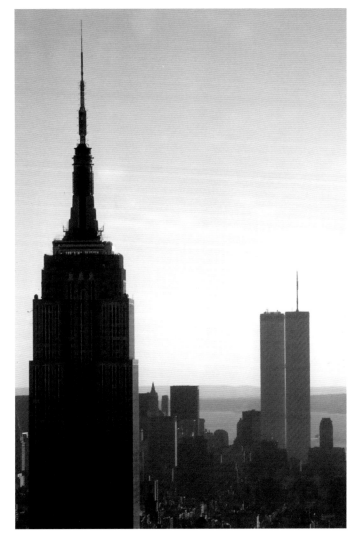

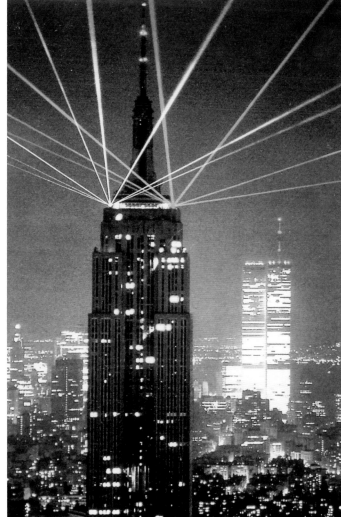

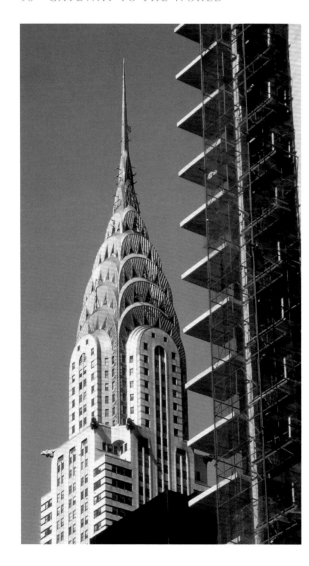

Left: Completed in 1929, the seventy-seven-storey Chrysler Building is beloved. Long considered one of the finest examples of art deco design, in recent years a committee of architects and architectural critics voted it as the 'most beloved older skyscraper' in all of New York City.

Walter Chrysler himself had an apartment in the turret and there had also been a restaurant at the very top, which was appropriately called the Cloud Club.

Right: Piers along the Upper West Side, well known as Luxury Liner Row, heralded the beginning of many trips to Europe. It all began with bon voyage parties, the sound of the ship's whistles and then those festive, paper streamer-filled sailings.

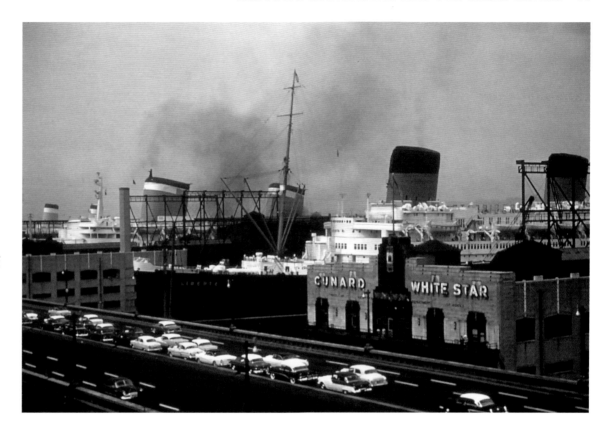

Luxury Liner Row was well known in the city and, in its heyday, stretched from Pier 84 at West 44th Street to Pier 97, West 57th Street. The piers themselves, dating from the twenties and thirties, were specially numbered. If one subtracted forty from the pier, one got the street location. So, if departing on, say, the *Cristoforo Colombo* or the *Independence* from Pier 84, it was 44th Street. On the *Queen Mary*, it was Pier 90 on 50th Street, or on the *Gripsholm* from Pier 97, it was 57th Street. By 1974, with the great decline of Atlantic liner service, three piers – numbers 88, 90 and 92 – were rebuilt as what was largely a terminal for cruise ships.

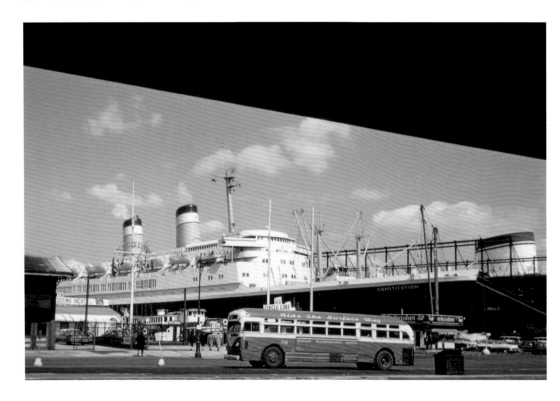

Luxury Liner Row in 1959: American Export Lines' *Constitution* is on the south side of Pier 84, the Italian *Giulio Cesare* just beyond. (Richard Weiss Collection)

The Great Liners: going to sea with Cunard

A steward with very long seagoing service once told me that to work for Cunard in the 1950s, just after the Second World War, was like working for the Bank of England. It was immensely prestigious. There was no better British shipping line to serve aboard. Liverpool-born Robert Welding, now living in Australia and long since retired from the sea, got an apprenticeship with Cunard in 1959. He was sixteen at the time. 'I was so fortunate. Cunard was top of the class,' he said, 'They were the crème de le crème. There was no better company for a career at sea. It was expected that I would become a top cook or even head chef.'

Robert Welding was first assigned to the Cunard sisters *Media* and *Parthia*, combination passenger-cargo ships of some 13,500 tons, which carried 250 First Class passengers only and lots of cargo. They ran regular Atlantic crossings between Liverpool and New York's Pier 92, making the trip in nine days in each direction. 'We had long stays in port at each end in those days', recalled Welding,

> We'd arrive in New York on a Saturday and then not sail again until the following Friday. That was six days in port and lots of ashore time for the crew. They were gorgeous little ships, beautifully decorated, like miniature versions of First Class on the big *Queen Mary* and *Queen Elizabeth*. We had lots of top business people on board, passengers who preferred more leisurely crossings and the occasional celebrity such as Katharine Hepburn.

Rather quickly, however, Welding was reassigned to the *Britannic*, a 27,000-ton ship that was the last of the old White Star Line (they had owned the *Titanic*, among many others) and a company that merged with Cunard in 1934 and together became known as Cunard-White Star. 'The *Britannic* was very popular on the Liverpool–New York run as well, but she also stopped at Cobh in Ireland in each direction,' Welding added,

> And she had a far greater capacity – 1,000 passengers altogether in First- and Tourist-Class sections. I was a cook on the *Britannic*, but Cunard had you work in other areas as training. So, I worked in the store rooms, in provisioning, even in the laundry and, briefly, as a steward. I stayed with the *Britannic* until the end of her days, in December 1960. She was thirty years old by then and tired. There had been some major mechanical problems just the summer before and, for the long repairs, the ship was idle at Pier 90 for weeks. She missed many top summer season sailings. In the end, she was stripped out at Liverpool and finished off. A skeleton crew took her up to Scotland for scrapping.

Cunard still had a large Atlantic liner fleet and so Welding was reassigned yet again – going over for one trip each (to Quebec and Montreal in the company's Canadian service) on the *Sylvania*, *Saxonia* and *Carinthia*. 'Cunard always moved you from ship to ship,' Welding remembered, 'but the menu and kitchen work never really changed from ship to ship.'

His next posting was to the most famous pair of big liners in the world, the *Queen Mary* and *Queen Elizabeth*. These were the Cunard giants, at over 81,000 tons and 83,000 tons respectively, carrying some 2,000 passengers and 1,100 crew. Hugely powerful, they made continuous five-day express crossings between New York, Cherbourg and Southampton. 'I worked aboard the *Queens* in 1961/62. I was assigned to the First Class restaurant and also did relief work in the select Verandah Grill,' he recalled. 'We prepared meals for the rich and

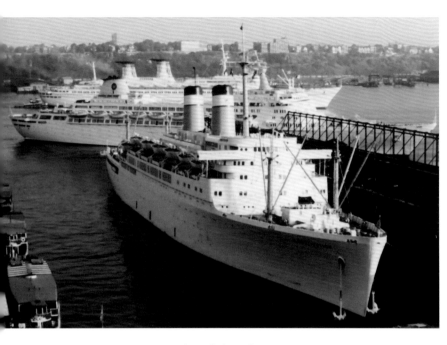

Constitution, Oceanic and Michelangelo.

Oceanic and Atlantic.

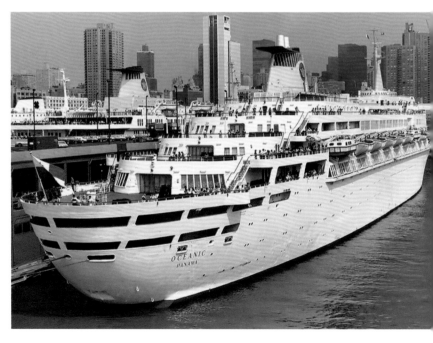

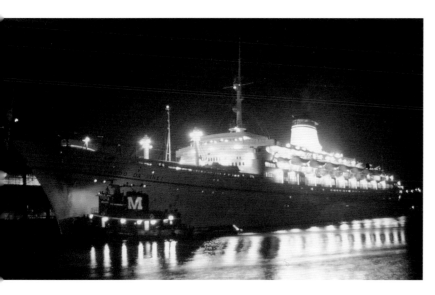

Leonardo Da Vinci.

Raffaello.

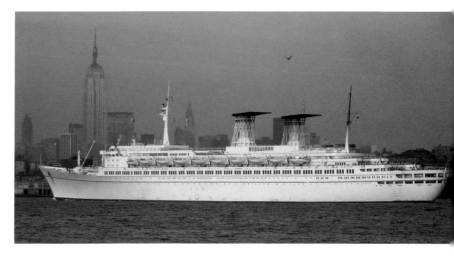

famous of the world including the likes of Lord Mountbatten, Lord & Lady Docker, Elizabeth Taylor and Debbie Reynolds.'

But the top job at Cunard was to go to the *Caronia*, the splendid 'Green Goddess', a roving, 34,000-ton luxury cruise ship that travelled the world. She did almost nothing but long, expensive cruises with 600 or so millionaires on board and 600 hand-selected crew. 'The *Caronia* was a magnificent ship and known to be the most luxurious in the Cunard fleet of that time. Many said she was actually the most luxurious liner in the world as well', added Bob Welding,

Within Cunard, it was very hard to get a job on her. Everyone wanted to work the *Caronia*. She had the most superb itineraries that were so desired by the crew. Only the best Cunard staff was sent to the *Caronia*. And if you went to her, you knew that you made it at Cunard. And, of course, there were all millionaires, largely American, on board and so she had the best tips. She was run like the grandest hotel, the best British country house. The caviar was unlimited, for example, the finest beef was carved at dining room tables and just about anything & everything the passengers desired was there. I spent three years on the *Caronia* and saw much of the world from her decks – Norway, Rio, Cape Town, India, Australia, Hong Kong, San Francisco, the Panama Canal. She had the most amazing itineraries. Altogether, I did three 100-day world cruises on her before leaving Cunard in 1964 for other seagoing adventures.

Arriving passenger ships at New York:

9–15 May 1957

Thursday, 9 May
Liberte, French Line: Le Havre, So'ton 9.00 a.m. 88 HR W 48 St
Santa Barbara, Grace Line: Valparaiso 8.00 a.m. 58 HR W 16 St
Santa Monica, Grace Line: Carib ports 9.00 a.m. 57 HR W 15 St

Friday, 10 May
New York, Greek Line: Bremerhaven 10.00 a.m. 88 HR W 48 St
Queen of Bermuda, Furness: Bermuda 8.30 a.m. 95 HR W 55 St
Ocean Monarch, Furness: Bermuda 9.30 a.m. 95 HR W 55 St
Ancon, Panama Line: Cristobal 8.00 a.m. 64 HR W 24 St
General Butner, MSTS: Bremerhaven 8.00 a.m. 4 Army Base Bkn
General Goethals, MSTS: San Juan 8.00 a.m. 4 Army Base Bkn

Saturday, 11 May
Cristoforo Colombo, Italian: Genoa 9.00 a.m. 84 HR W 44 St
Britannic, Cunard: Liverpool 1.00 p.m. 92 HR W 52 St
Covadonga, Spanish: Cadiz 9.00 a.m. 15 ER Maiden Ln

Sunday, 12 May
No arrivals

Monday, 13 May
Kungsholm, Swed-Amer: Gothenburg 9.00 a.m. 97 HR W 57 St
Noordam, Holl-Amer: Rotterdam 8.00 a.m. 5th St Hoboken
Brazil, Mor-Mac: Buenos Aires 8.00 a.m. 32 HR Canal St
Santa Luisa, Grace: Valparaiso 8.00 a.m. 57 HR W 15 St

Tuesday, 14 May

Queen Elizabeth, Cunard: So'ton	9.00 a.m. 90 HR W 50 St	
United States, US Lines: Southampton	8.00 a.m. 86 HR W 46 St	
America, US Lines: Bremerhaven	1.00 p.m. 86 HR W 46 St	
Mauretania, Cunard: Southampton	2.00 p.m. 90 HR W 50 St	
President Polk, Amer Pres: Med ports	9.00 a.m. 9 Jersey City	
Santa Sofia, Grace: Caribbean ports	8.00 a.m. 58 HR W 16 St	

Wednesday, 15 May

Independence, Amer Export: Genoa	9.00 a.m. 84 HR W 44 St	
Giulio Cesare, Italian: Genoa	8.00 a.m. 84 HR W 44 St	
Statendam, Holl-Amer: Rotterdam	9.00 a.m. 5th St Hoboken	
Santa Paula, Grace: Caribbean ports	8.00 a.m. 57 HR W 15 St	

Wartime passage

Transport by ship in the dark days of the Second World War created many unique, unusual (other very strange), even frightening situations. Ships were painted in wartime dress, in grey paints mostly, and all as the great ocean liners lost their deep comfort and high luxuries. They were pressed into service as troop transports. Priscilla Norton remembers a crossing in the Nazi sub-infested waters of the North Atlantic aboard the legendary *Ile de France*, then being used as a huge Allied trooper. That passage was notable, especially for twenty-three-year-old Priscilla – she was one of only five females onboard among the 10,000 men, mostly GIs headed overseas. 'I was multi-lingual and assigned to the OSS, the Office of Strategic Service. But I was not important enough to fly to Europe and so was sent ship,' she recalled as we sat together in a lounge aboard Cunard's *Queen Victoria*, a ship that would carry Priscilla on a 105-night luxury cruise around the world. Young Priscilla had always 'loved the water', as she put it, and had sailed in the 1930s to and from Europe aboard such liners as the *Pennland* and *Westernland,* the *Rotterdam* and the big German super liners *Bremen* and *Europa.*

> I was specially recruited to go to France. It was September 1944 and the war itself would last another eight months to go. I was sent by troopship, on board the famous *Ile de France.* But it was all cloak and dagger at first. It was all top secret. I had to wait a full week in New York City and was made to move hotels several times. We had our military luggage moved for us, but our civilian clothes could be moved by Manhattan taxis. One day, we were finally ordered to a pier on the West Side. We boarded the *Ile de France,* which was painted entirely in gray and which was docked next to another grey troopship, the *Queen Elizabeth,* which was taking on 15,000 soldiers. Our ship was not identified, but as we boarded we could see the name *Ile de France,* which had been painted over. I was excited. Family friends had sailed to Europe on the *Ile de France* in the late 1930s.

Like all big, high-capacity troopships, the 43,000-ton *Ile de France* travelled on a top-secret route, blacked out and with radio silence. Like other ships, the *Ile* was a prime target to the sinister Nazi subs. The *Ile*, which was managed by the Cunard Line during the second half of the war on behalf of the Free French forces, took over a week to cross the North Atlantic. 'We sailed on a very northern, quite cold route to Gourock in Scotland. We landed at the Firth of Forth,' recalled Priscilla some sixty-six years later,

> We were not allowed to mention the name of the ship, but when I later wrote home, I mentioned 'red roses in the carpet'. My

family might remember that from our visit to the *Ile* years before. I was assigned to a single cabin with a tub bath and shower. But it was rearranged with bunks for nine, but there were only six occupants on that trip. Otherwise, the ship was heavily laden with people during that crossing. There were meals twice a day, breakfast and dinner, but you could make a sandwich at breakfast and then have it as lunch. There was no alcohol. It was officially forbidden. The crew was mostly British, provided by Cunard. The British captain invited the five women for drinks, non-alcoholic ones, of course. Actually, it was quite scary to be with 10,000 soldiers and crew!

There were rituals to wartime travel, especially for a young woman on a soldier-filled troopship …

You needed a 'protector' and I managed to have three or four of them. No contact was allowed with the enlisted men, but you had to go through the all-male areas at least twice a day on the way to the mess. Of course, we were also aware of possible torpedo attack followed by a quick sinking. There were a few officers on board who had been in the First World War and recalled their duties back then. The *Ile* was almost unrecognisable during that crossing. She had been totally changed and altered from the comfortable glamour of pre-war. The big piano was still in the converted main salon, however, and so there were lots of sing-alongs. Some songs were actually too sentimental and brought a few tears. But the ship was always noisy. The loudspeakers were going constantly. And there was smoking everywhere. We had blackout curtains on the windows. We carried our lifejackets at all times and used them as seats, which was officially forbidden. But we huddled everywhere. We played lots of bridge to pass the time. I won $5 at bridge, but gave it to the boys for drinks.

A bottle of black-market scotch was $35, which was a huge amount of money back then. And there was lots of gambling amongst the men. It took ten days to cross and then we had to wait off Gourock for two days. By then, everyone seemed restless and very anxious.

Priscilla was later posted to Paris and then sent home by air just as the war ended, in May 1945.

Cruising to the sun: the very popular *Oceanic*

At lunchtime on a sunny April day in 1965, New York harbour was noisier than usual – a new liner was arriving in port for the first time. Tugs created a welcoming escort, fireboats sprayed and helicopters buzzed overhead. The ship, all white with a flared bow and a funnel placed aft and resembling, say, an oil tanker, she caused a stir, something of a sensation. She was the 39,000-ton *Oceanic*, owned by the multi-national, but immensely popular, Home Lines. She flew the Panamanian colours, however, a flag of convenience that avoided taxation as well as the likes of crew unionisation and regulations. New York dockers, among others, were somewhat resentful and dubbed her a 'Runaway Flagship'. But she was a great sensation: glorious interiors in her 774-foot-long hull, twin pools covered by a retractable glass ceiling and Home Lines' renowned food and service.

The 27-knot, Italian-built *Oceanic* was also a great innovator – in the infancy of year-round cruising, she offered weekly departures (ever Saturday afternoon at 4 p.m.) from New York on seven-night cruises to Nassau and back. Minimum fares were $175 and went up to as much as $1,000 for a top-deck

suite. In winter, between December and April, she made longer cruises – ten to twenty-one trips around the Caribbean islands. Booked months and sometimes years in advance, the exquisite *Oceanic* had legions of loyalists. For twenty years, she was a beloved fixture in New York harbour.

Sold to Premier Cruise Lines in 1985, she was marketed as the *Starship Oceanic* for twice-weekly cruises over to the Bahamas from still-budding Port Canaveral. In 2000, she became the *Big Red Boat I*, but soon reverted to *Oceanic*. After Premier collapsed two years later, the 1,136-berth ship passed over to Spain's Pullmanturs, running weekly cruises in and around the western Mediterranean from Barcelona.

But time was running out by 2008. Against her forty-three years, she had become less and less economical. Anthony Cooke, the London-based ocean liner author and marine book publisher, took one of her last cruises, joining a group of sentimental aficionados from the Ocean Liner Society:

> She still had lots of her original, 1965 artwork onboard. There was something of the 'time capsule' about her. For the Spanish, she had become the 'honeymoon ship'. She'd leave Barcelona every Monday, a convenience for Saturday marriages. She carried mostly younger passengers. The average age was thirty-five, but some were as young as eighteen and nineteen. The Spanish passengers were fun and often noisy, but never annoying. On our cruise, there were also lots of Spanish-speaking South Americans on board.

But the *Oceanic* has gone on to a new, quite different life – as the roving cruise ship for the Japan Peace Boat Society. Her voyages, which are mostly world cruises, included a visit to familiar waters – to New York – last June. *Ocean & Cruise News* chief editor Tom Cassidy went aboard for a sentimental visit and reported,

> The *Oceanic* visit was great, so nice to see that favourite ship again. I sailed on her twice and visited numerous times in the 1960s and '70s. Little remains of the original interior décor, but you could stroll the public rooms and corridors and remember her as she was. Many of us had old deck plans and brochures in hand. A very nice visit.

There were troubles for the liner, however. According to Tom Cassidy, 'Seems that the Coast Guard did a throw inspection, even with divers below the water line, and found a leak so she was not allowed to sail on Saturday as scheduled and she is actually now [June 28 2009] in dry dock in Bayonne until who knows when.' The *Oceanic* had not been to the Big Apple in twenty-four years.

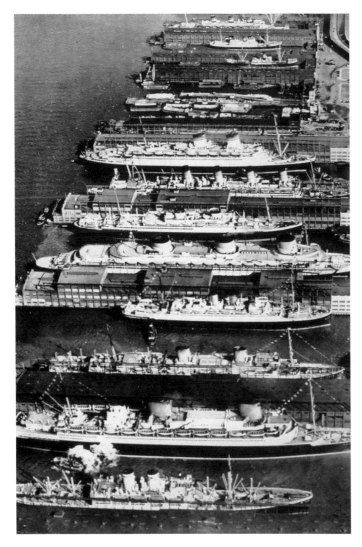

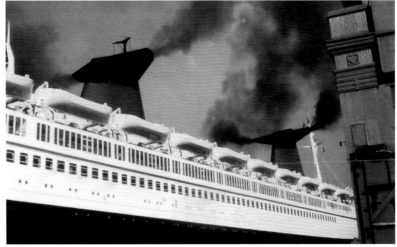

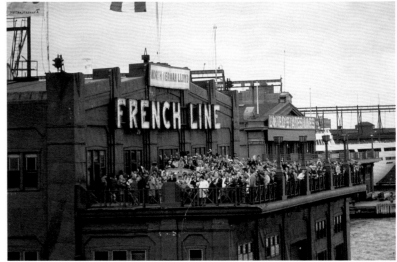

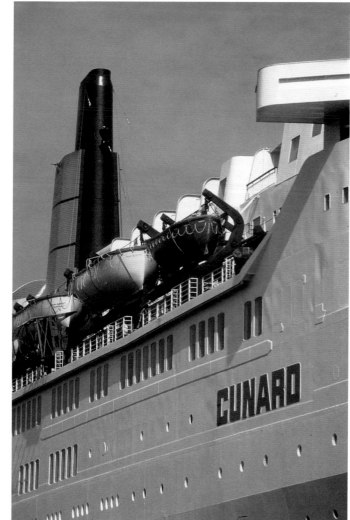

Above: Cruise liners, mostly on weekend sailings, used what had become the New York Passenger Ship Terminal beginning in the mid-1970s. In this view, the *Dreamward, Horizon* and *QE2* are in port together.

Right: Trans-Atlantic crossings all but disappeared by the 1980s except for the seasonal trips of Cunard's *Queen Elizabeth 2*. Retired in 2008, the *QE2* was replaced, however, by the even larger *Queen Mary 2*.

Opposite left: Grand heyday: Luxury Liner Row on a Saturday morning in February 1939, showing (from top to bottom) *Monarch of Bermuda, Conte di Savoia, Aquitania, Britannic, Normandie, De Grasse, Columbus, Bremen* and *Hamburg.*

Opposite right: If 2,000 passengers were sailing, say, aboard the *Queen Mary,* there might as many as 5,000 well-wishers, family and friends and just general visitors. They paid fifty cents to board, attended bon voyage parties and toured the liner's glamorous innards. They had to disembark 30 minutes before actual sailing. At departure, some went to the very end of the 1,100-foot-long piers for those last farewells.

Tiny tugs undock the mighty *France,* 1,035 feet in length and the world's longest liner in the 1960s. The French Line flagship, she was a great favourite at New York.

Above: Visiting military ships are still very popular, drawing crowds during mostly weekend, open-house visits.

Below: The USS *Intrepid*, a Second World War vintage carrier, was added to the West Side, at Pier 86, in 1982. It has been a popular aviation museum.

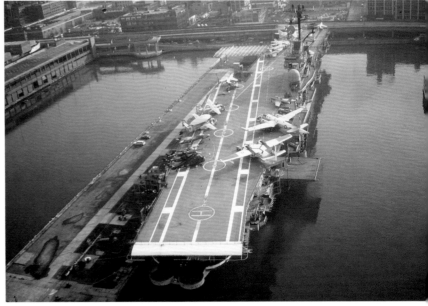

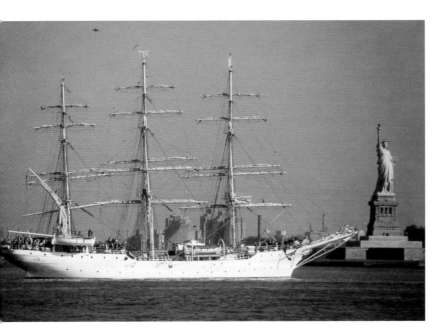

Above: The graceful Tall Ships still come to call and are popular with visitors.

Below: As shipping declined in New York harbour, pleasure boating increased. There are far more weekend sailors as well as regattas and contests, such as the Mayor's Cup Sailing Race, and even an annual tugboat race.

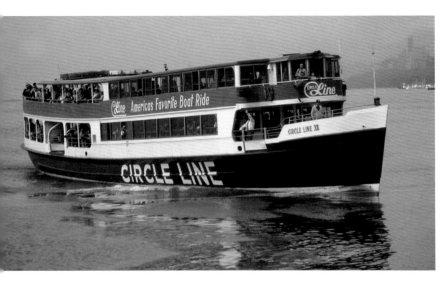

Above: The Circle Line, with its fleet of excursion craft, offer cruises around Manhattan Island and special sailing, including city night lights, as well.

Below: There were 400 tugs working in and around New York harbour in 1955; by 2014, this number had dropped to just over fifty. Alone, big, deep-sea ships no longer require as much assistance from tugs.

This page and overleaf: Some of the varied tugs in New York harbour in the 1950s, '60s and '70s.

Above: The harbour's working craft – oil barges, floating cranes and general work boats – have declined as well. There is, quite simply, less need in more recent times.

Below: These days, Manhattan by night is as beautiful as ever. More towers are lighted, for example. It is much like sparkling diamonds laid out on black velvet.

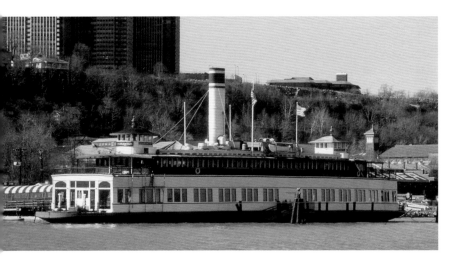

Above: The 1905-built Lackawanna Railroad ferry *Binghamton* was retired in 1967, but found later life as a floating restaurant moored along the upper Hudson, at Edgewater, New Jersey. Popular for some time, it later declined, slipped in bankruptcy (by the late 1990s) and was lying as wreck as of 2014.

Below: While most railroads pulled out of the ferryboat business in the 1950s and '60s, newly formed New York Waterways restored ferry service in the late 1980s. With a scant two dozen passengers on its first day of operations between Weehawken and Manhattan, it has grown to several hundred thousand per day.

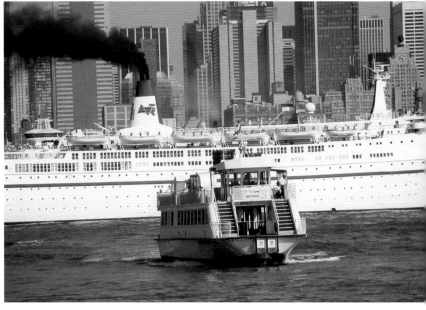

Left: Built in 1931, the George Washington Bridge, with a span of 3,500 feet, connects Fort Lee, New Jersey with Upper Manhattan.

Above: Originally intended to be covered in stone, the George Washington Bridge was finished in exposed steel, a result of cost cuts during the early Depression era.

Chapter Six
THE EAST RIVER AND THE BROOKLYN DOCKS

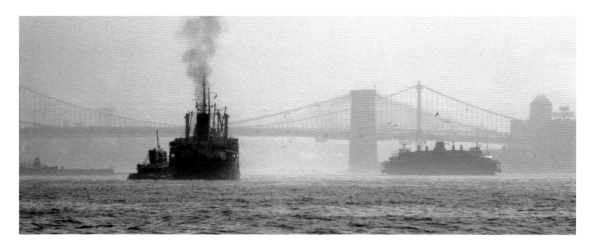

Traffic along the East River, which winds its way up to Long Island Sound, declined greatly by the 1960s. Deep-sea shipping traffic disappeared largely in the face of barges and pleasure craft.

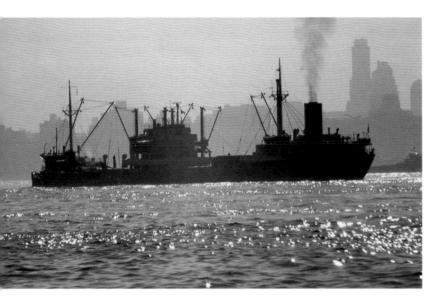

Above: A Greek tramp steamer enters the East River on a bright summer's morning.

Below: The three initial bridges along the lower East River are among the city's finest: the Williamsburg (far left), the Manhattan (middle) and the Brooklyn (right).

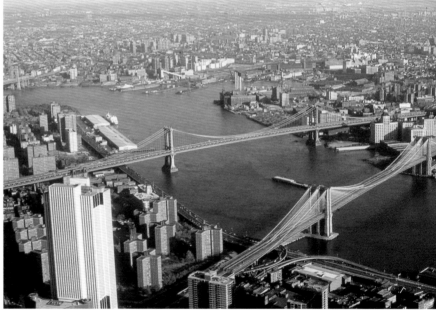

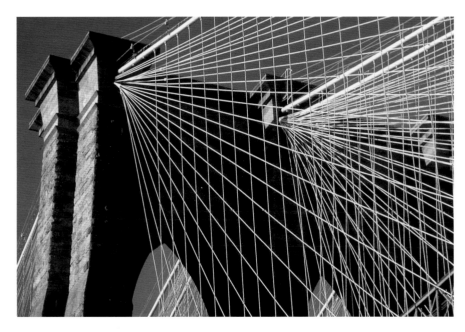

Above: The Brooklyn Bridge, opened in 1883 and connecting Lower Manhattan and Brooklyn, is generally considered the most beautiful of the older harbour suspension bridges.

Right: Developed in the late 1960s, South Street Seaport served for many years as a museum, home to old craft and in tribute to the city's nineteenth-century maritime past. In later years, there was also an ocean liner museum. Largely closed after storm damages (in 2013) and subsequent financial problems, it is now scheduled to be redeveloped as a shopping and high-rise apartment tower complex.

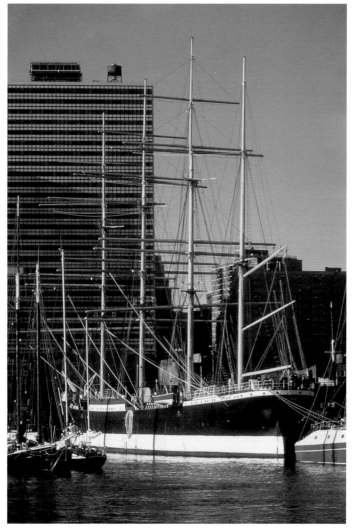

Bound for Havana: the Spanish Line at Pier 15

Pier 15 at the foot of Maiden Lane was the home, in the 1950s, of the Spanish Line and their twin passenger-cargo ships, the 10,200-ton *Covadonga* and *Guadalupe*. Built in the early 1950s in Spain, they were comparatively small ships but carried up to 350 passengers each in two classes, First and Second. By the fifties, they were just about the only passenger ships still sailing from New York's Lower East Side, along the East River. They traded across the mid-Atlantic to and from a collection of Spanish ports, but then, after calling at New York, made extended sailings to the Caribbean, stopping at Havana (replaced by San Juan after Castro arrived in 1959/60) and Vera Cruz. The Spanish Line was represented in New York by agents Garcia & Diaz, which occupied smallish offices along lower Broadway and neighbouring with the mighty, very grand offices of Cunard.

Myself, I recall visiting these ships, which were very Spanish in style, very dark wooded and which included religious altars in the corridors. Also, the smell of Spanish cooking permeated throughout the ships.

The 487-foot-long *Covadonga* and *Guadalupe* visited New York every two weeks and then remained in port for four or five days, offloading and then loading cargo. They'd deliver the likes of coffee from the Caribbean, wines and olives from Spain and, on outward trips, took on American manufactured goods.

Their trade inevitably fell away and by the late 1960s, both ships were downgraded to freighter status, limited only to twelve passengers each. By then the Spanish Line had relocated as well, to Harbourside Terminal in Jersey City. Passenger ship sailings from East River berths had ended.

Zim Lines in Greenpoint, Brooklyn

As the state of Israel was established in 1948, so was the national shipping company, the Zim Lines. They later established services to New York, including a passenger line from Haifa and other Mediterranean ports, using a veteran, second-hand liner, the former Norwegian *Bergensfjord* of 1913. She had been renamed *Jerusalem*.

An Israel–West German reparations pact of the early 1950s included the construction in German shipyards for four brand new passenger ships: two combination passenger-cargo liners for the Atlantic run to New York, and two for more localised inter-Mediterranean service. Zim directors at the time felt that combination ships were more ideal and more profitable, carrying passengers as well as cargo, for a regular service to and from New York.

Having very sleek design with single, tapered funnels and sharply raked bows, the two 9,800-ton ships were constructed in Hamburg. The *Israel* was commissioned first, in September 1955; the *Zion* followed in February 1956. Newsworthy at the time, they were the very first passenger ships to be built for Israeli interests. To many, it was the beginning of what might become a large and important fleet.

Their accommodations were rather limited by Atlantic standards, however. There were only twenty-four berths in a small, secluded First Class section, 232 in Tourist Class and a further fifty-six beds that were interchangeable. With 18-knot service speeds, the twin ships could maintain a monthly balance of sailings, mostly trading between Haifa, Piraeus, Naples, Palma de Majorca, Gibraltar and New York. Occasionally, there was a westbound call at Halifax as well, purposely to land

Canada-bound immigrants. Because of their cargo ship nature, the turnaround at New York tended to be four to six days. Additionally, especially for passenger ships, these Zim ships berthed in rather remote Greenpoint in Brooklyn, at the Kent Street pier, which was directly across the East River from East 23rd Street. In the 1950s, it was a very busy, almost crowded time in New York harbour. Simply, while Greenpoint was less convenient, it was one of the very few berths available.

The 501-foot-long *Israel* and *Zion* saw nearly a decade of useful service. By the mid-1960s, however, both their passenger as well as cargo earnings were declining. The passenger trade had shifted although quite briefly to the brand new *Shalom*, Israel's new flagship and largest liner. Mostly, however, the trade would soon go to the airlines. At the same time, the cargo was going to less expensive ships compared to Israeli-flag vessels, which had very high, unionised labour costs, and then to more efficient container ships. The situation was closely reviewed by Zim managers and accountants in 1966. Rather quickly, both the *Israel* and *Zion* went to the block.

The *Israel* was sold to the Portuguese, while the *Zion* was rebuilt as a cruise ship, the *Dolphin IV*.

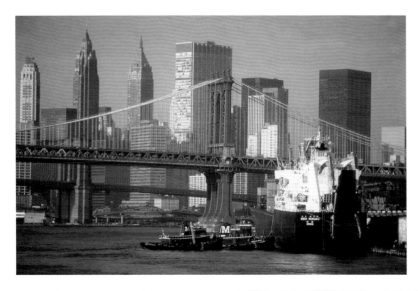

Left: The last working freighter pier, Pier 36, was along the East River. It closed in 1992.

Right: A rare visitor to the East River, to a pier at East 23rd Street, was the Soviet passenger ship *Baltika*. She carried Nikita Khruschev to a summit at the United Nations in 1959.

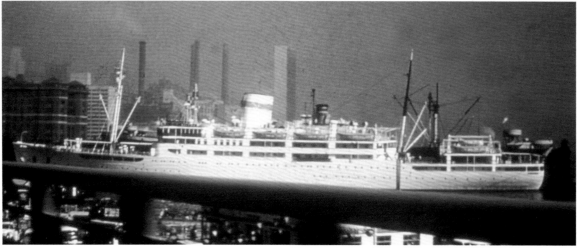

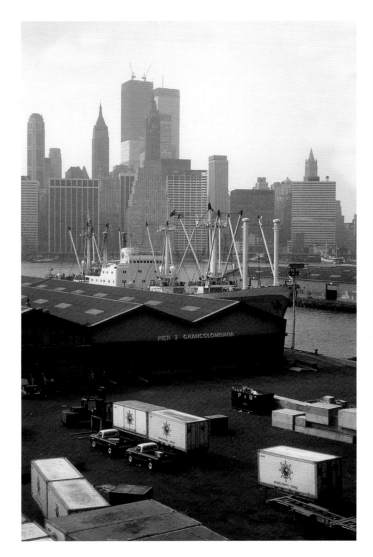

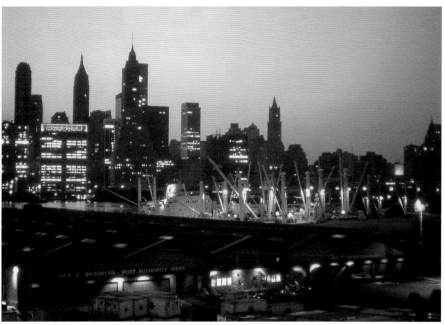

This and next page: The vast Brooklyn waterfront of over fifty steamship piers, as well as shipyards and the likes of grain and sugar terminals, boomed until the 1960s and '70s. Again, there was a great exodus of shipping lines to new, more spacious container terminals. By 2015, there was but one working container-cargo terminal along the Brooklyn waterfront.

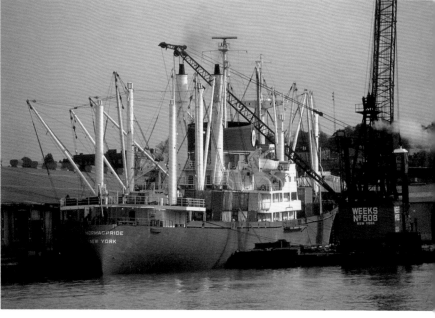

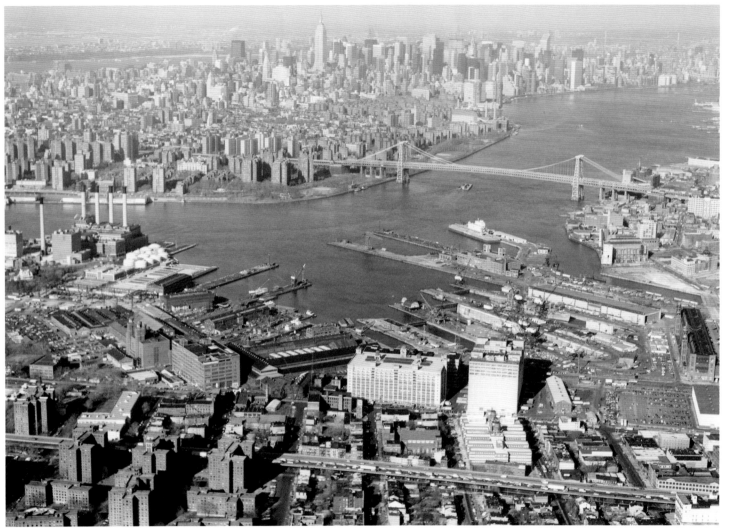

The Brooklyn Navy Yard employed over 70,000 people during the Second World War. Warships, including battleships and aircraft carriers, were constructed there. It closed in the early 1970s and part of the facility became a privately owned shipyard. (James McNamara Collection)

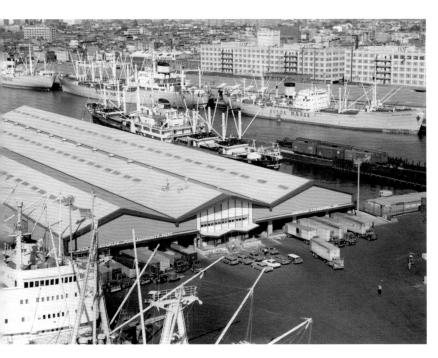

Below: In 2006, the Brooklyn-Red Hook Passenger & Cruise Terminal was opened. The *Queen Mary 2* is a regular visitor. (Cunard Line)

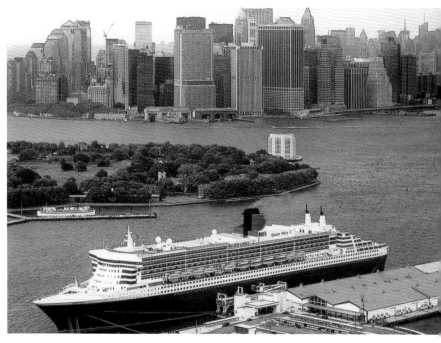

Above: A busy day at the Atlantic Basin terminal in Red Hook, Brooklyn in the 1960s. A main tenant was the Maersk Line. (Port Authority of New York & New Jersey)

The Brooklyn Army Terminal

In the spring of 1930, a largely unknown German actress arrived at New York for the first time. While she had some success at Berlin's UFA Studio, it was the magical lure of Hollywood, in particular the great Paramount Studios, which drew her across the Atlantic. Quickly, she became a major star, an international celebrity, indeed one of the great goddesses of Depression-era filmdom. Her name was Marlene Dietrich and she arrived aboard the *Bremen*. At the time, the ship's owners, the North German Lloyd, were using Pier 4 of the Brooklyn Army Terminal. In retrospect, it seem a most unlikely location for the glamorous Miss Dietrich to set her slender foot on American soil for the first time. With the *Bremen* long gone (lost to fire in 1941) and Dietrich herself dead (1991), the story seems complete: by the late 1990s, the old Brooklyn Army Terminal piers were in ruins. Two of the 1,800-foot-long docks had collapsed and settled into the Lower Bay waters off 58th Street; the third of the piers had long since been demolished.

Built in 1919 and completed in record time, the army terminal was a consequence of the First World War and the need of the US government to expand its shipping capabilities. The Norwegian America Line, with passenger liners such as the *Bergensfjord* and *Stavangerfjord*, took an early sublease at the docks. North German Lloyd joined as well and was there until 1934, when the likes of the *Bremen*, *Europa* and *Columbus* shifted northward, to Pier 86 along the Hudson River at West 46th Street. Lloyd publicists had worked hard to overcome the inconvenience of that distant Brooklyn berth, however. Enthusiastically, they reported, 'You are that much closer to Europe when you sail from Brooklyn on the Lloyd liners to Europe!'

After the Second World War, the terminal was used mostly by MSTS, the Military Sea Transportation Service, which ran a fleet of large troopships that carried American military personnel, and often their families, on postings to such overseas entry ports as Southampton, Bremerhaven and Rota in Spain. Perhaps the most famous departure of a serviceman from Brooklyn was in 1958 when the *General G. M. Randall* departed for Germany. Waving farewell from the ship's open decks was a young Elvis Presley. An especially large crowd, including many adoring fans, was there to see him off.

America shifted to air transport for all troops by 1973 and soon afterward the terminal all but closed. A freighter company, the Greek-flag Hellenic Lines, was the very last to use the docks and the bankrupt cruise ship *Victoria* one of the last ships to tie-up alongside in the summer of 1975. By the late 1970s, the terminal doors were locked tight.

In October 1998, New York City celebrated the works of architect Cass Gilbert. Among his works was the Woolworth Building, the Federal Court House on Foley Square and the Brooklyn Army Terminal. On a Sunday afternoon, a chartered ferry took visitors down to those old, forlorn docks. I wondered if anyone mentioned those big German liners and the first arrival of Marlene Dietrich.

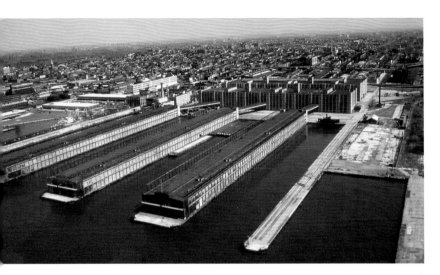

Above: The Brooklyn Army Terminal, with four 1,800-foot-long finger piers and a vast adjacent office and warehouse space, was built in 1919. Used by military troopships until the 1970s, it then fell into disuse and was later demolished.

Below: When I took this photo, in March 1977, the army terminal was all but closed completely. The 'Welcome Home' message was a last hint of welcoming home troops arriving by sea. Painted at the far end of Pier 4 of the terminal, it was demolished soon thereafter.

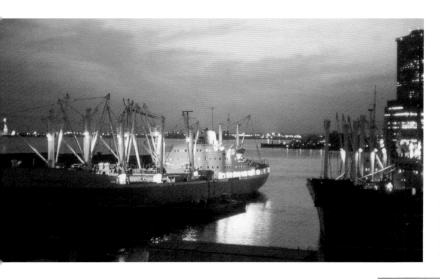

At the end of a busy day in the harbour, general commerce activity and shipping lessen. The sun sets over in the west, over New Jersey, and nightfall comes. But even at night, there is still a moving ship or two, a shuttling ferry and a tug with a barge in tow. Like the city itself, the great port of New York never quite goes to sleep.

BIBLIOGRAPHY

Braynard, Frank O. & William H. Miller, *Picture History of the Cunard Line 1840–1990.* (1991)

Kludas, Arnold, *Great Passenger Ships of the World Vol. II.* (1976)

Kludas, Arnold, *Great Passenger Ships of the World Vol. III.* (1984)

Miller, William H., *Pictorial Encyclopedia of Ocean Liners, 1860-1994.* (1995)

Miller, William H., *Picture History of British Ocean Liners: 1900 to the Present.* (2001)

Miller, William H., *Picture History of German and Dutch Passenger Ships.* (2003)

Miller, William H., *Picture History of the French Line.* (1997)

Miller, William H., *Picture History of the Italian Line.* (2000)

Miller, William H., *The First Great Ocean Liners in Photographs 1897-1927.* (1984)

Along the Hudson: Luxury Liner Row in the 1950s and 60s

William H. Miller

William H. Miller tells the story of the ships on Luxury Liner Row, with many photographs illustrating the glamour, the luxury and the sheer buzz of New York's waterfront in the 1950s and 60s.

978 1 4456 0555 5

128 pages, illustrated throughout